Cincinnati's Great Disasters

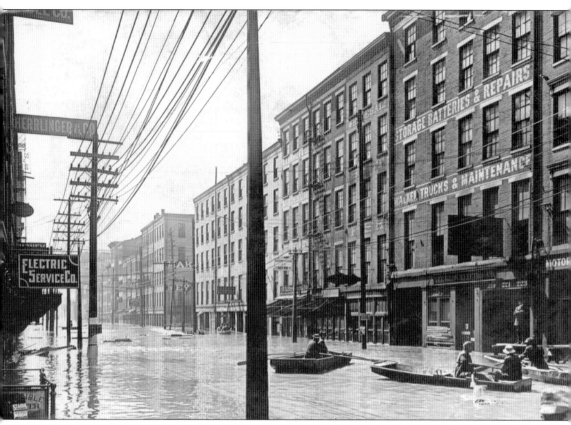

Cincinnati periodically has had large floods, once dubbed the "yellow peril," the result of a combination of rain fall and geography. Heavy rains would swell the Ohio River and its numerous tributaries and, with no dams to slow the rise of the waters, flood stage would be rapidly reached. Basin-shaped downtown was slightly above flood level, and "the Bottoms" would be inundated nearly every year. Today's Cincinnati is the second site for the city. The original settlers landed slightly upriver around Columbia Tusculum-Lunken Airport, where the Pioneer Cemetery is located. They moved downriver to the current site because of even worse flooding problems there. (Courtesy of the collection of the Public Library of Cincinnati and Hamilton County.)

On the cover: The earliest settlement in this area was Columbia (Wilmer Road and Lunken Airport), founded on November 18, 1788, by Maj. Benjamin Stites. Some of these settlers moved downriver to Losantiville, founded on December 18, 1788, because of Ohio River flooding. Of the many times that the river has reached flood stage, the years of 1884 (71.1 feet), 1913 (69.9 feet), and 1937 (79.9 feet) set records. This postcard is of the 1913 flood. (Courtesy of the collection of the Public Library of Cincinnati and Hamilton County.)

POSTCARD HISTORY SERIES

Cincinnati's Great Disasters

Betty Ann Smiddy
with support of the Public Library of Cincinnati and Hamilton County

ARCADIA
PUBLISHING

Published by Arcadia Publishing
Charleston SC, Chicago IL, Portsmouth NH, San Francisco CA

Printed in the United States of America

Library of Congress Catalog Card Number: 2007923420

For all general information contact Arcadia Publishing at:
Telephone 843-853-2070
Fax 843-853-0044
E-mail sales@arcadiapublishing.com
For customer service and orders:
Toll-Free 1-888-313-2665

Visit us on the Internet at www.arcadiapublishing.com

To the Public Library of Cincinnati and Hamilton County whose books have shown me a wider world. And to those folks that relish the smell and feel of being the first to open a new book.

CONTENTS

ACKNOWLEDGMENTS

I would like to thank Kimber L. Fender, executive director of the Rare Books and Special Collections Department; Sylvia V. Metzinger, former manager of that department; and Patricia Van Skaik, current manager of History, Genealogy and Rare Books, for their approval of this project; Diane Mallstrom, reference librarian Rare Books, and Claire Smittle, also of that department; John R. Reusing, development director, for his enthusiasm, (all of the aforementioned are employees of the Public Library of Cincinnati and Hamilton County); Glen Horton, technology coordinator for the Southwest Ohio and Neighboring Libraries, for his assistance with the computer images from www.cincinnatimemory.org; my Arcadia Publishing editor, Melissa Basilone, who has been a joy to work with; the Cincinnati Historical Society library, an underappreciated resource and a quiet place to research; my husband, Bruce A. Buckner, for proofreading and correcting my sometimes torturous sentences; Jonathan Burkhardt for his computer expertise; Constance Lee Menefee for her encouragement and computer assistance; and Don Prout, who has been very generous in allowing me to use the postcards from his Web site, www.cincinnativiews.net. Unless otherwise indicated postcards are from the collection of the Public Library of Cincinnati and Hamilton County.

INTRODUCTION

Deltiology, or postcard collecting, has been a popular pastime for over a century. As a hobby, it has something for everyone, from exotic locales to individual holidays. Merchants have used them for advertising, regional recipes are always a hit, and some tell stories, poems, songs, or jokes. Buildings, art, cars, children, and greetings add more categories to collect. A small niche is local disaster photographs.

Something seems special when you are sent a postcard. Better than a note, there is a feeling the picture was chosen especially for you and the short messages assure that you are remembered. Postcards bring smiles and are often kept. This accounts for the number of very old postcards that are found today in attics, antique stores, flea markets, and postcard shows.

The first postcard where postage was affixed, rather than printed on the card by the government, was made in 1869 in Austria. The following year, postcards were being printed and mailed throughout Europe, which would dominate the postcard market until World War I.

The popularity of the postcard in the United States can be dated from 1893, when the World's Columbian Exposition was held in Chicago. These colorful cards were of the buildings and views of the exposition. Some were government printed with a penny stamp. Others that were privately printed were considered souvenir cards and needed a 2¢ stamp affixed before mailing. All bore messages written across the front because before March 1, 1907, it was illegal to use the back, except for the address. These cards had an undivided back.

The earliest of this book's postcards were black-and-white photographs printed on a postcard back. Postcards in color were usually printed in Europe, which had captured 75 percent of the market. German companies were the primary printers. Locally, Albert J. Kraemer and the Kraemer Art Company manufactured attractive postcards that were retouched and printed in Berlin. After March 1, 1907, postcards had a divided back, allowing for a longer message than what could fit on the front and made the photograph front more desirable. This launched postcard collecting as a major hobby, which lasted until World War I. Postcards were kept in special albums or displayed in a parlor wall rack. According to post office records, 677.8 million postcards were mailed during the fiscal year ending June 30, 1908. The United States population stood at 88.7 million at that time.

Because of World War I, German lithography stopped; thus no more high-quality postcards were being manufactured. The American and English postcard industries were a poor second in quantity and quality. After the war, Germany's printing industry did not recover. The United States then began to dominate the industry. The quality improved, but to save money, white borders were added. The hobby of collecting also declined; the telephone was the new way to send a message.

The disaster postcards were made to memorialize an event, rather than send greetings. They eventually fell out of use because of advances in photography. The first photographic images printed were tintypes, followed by the carte de visite, which were popular during the Civil War. The latter used a glass negative and multiple copies could be made of a photograph. The big drawback to the glass negative was that it had to be developed by the photographer. The first handheld camera that used a roll of film was developed by George Eastman in 1888. The camera, with the film still inside, was sent back to the factory for development. The camera was returned with a new roll of film along with the developed prints. The negatives themselves were as large as three and a half inches by three and a half inches. In 1900, the Brownie camera was introduced, costing $1, and film was a dime a roll. While this sounds inexpensive, a loaf of bread at that time cost a penny and potatoes were 3¢ a pound.

Newspapers relied on sketches for their papers until the halftone printing process was invented, which allowed photographs to be printed. The first photograph in the *Cincinnati Enquirer* was published on September 5, 1898, being of the Grand Army of the Republic (GAR) encampment. At first the newspapers contracted professional photographers for their pictures, using mainly head shots to illustrate articles. Sometimes these same pictures were used for postcards. It was not until later that a staff photographer position was added.

Newspaper clippings are fragile and many people bought postcards of an event as a way to remember it. It was years before the middle class could afford a camera, and when they could, disaster postcards were no longer made. In 1906, the folding pocket camera was developed. It changed the world of news by showing photographs of the great San Francisco earthquake. Average people, not only professionals, could photograph the world as they saw it. This new camera cost $5–$7. As time passed, the cameras and film both improved, the relative price declined, and ordinary folks now could shoot their own photographs, making disaster postcards obsolete.

One

WATER

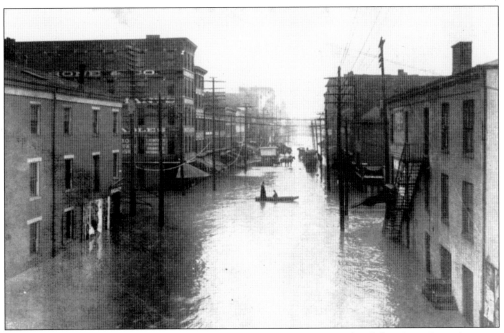

Front Street was located behind Water Street, the first street north of the river. Running east and west on Front Street, the gasworks was located west of Seventh Street near Rose Street and the waterworks was located parallel to Mount Adams. Near the waterworks was the Lexington and Nashville Railroad (L&N) depot. This area was crisscrossed with railroad tracks. The cheap tenements of "Rat Row" and "Sausage Row" had mostly been torn down in this area, replaced by the railroads and coal yards by the January 1907 flood.

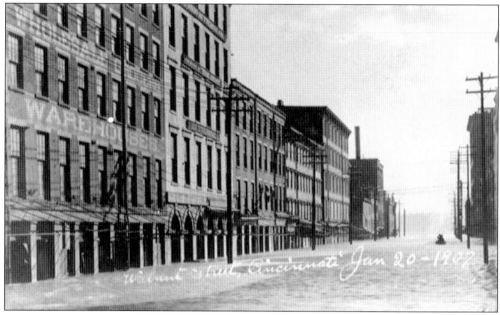

This is lower Walnut Street in 1907, a day before the Ohio River crested. To the left is a wholesale grocery warehouse. One of the largest warehouses in this area was the Charles McCullough Company, which sold seeds. Carried to the upper floors were 9,000 sacks of seeds, and five wagonloads were moved to another location. Overloading the upper stories sometimes caused these older buildings, undermined by floodwaters, to collapse. (Courtesy of Don Prout.)

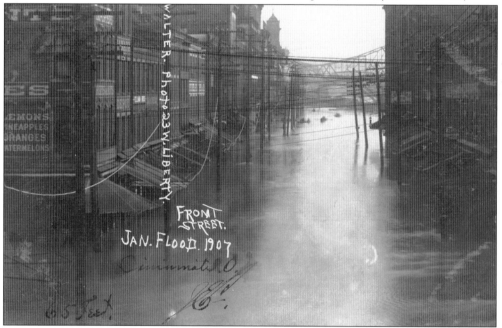

Front Street, with the Suspension Bridge in the background, is seen here flooded. Rain continued from Pittsburgh to Cincinnati for days, and Chicago experienced sleet, rain, and snow. The Shinkle, Wilson and Krels Company, wholesale grocers at Front and Vine Streets, had its basement and first floor underwater, although much of the stock had been moved to upper floors.

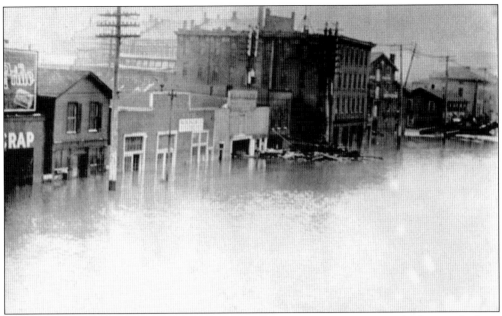

The canal brought high waters into business and residential neighborhoods that might have otherwise remained dry. The City Relief Corps, Salvation Army, and United Charities distributed food and clothing. Soup kitchens were set up. Muth bakery donated 1,000 loaves of bread and an unlimited supply at 2¢ a loaf. Ration packages were distributed containing bread, canned beef, sugar, coffee, and coal. (Courtesy of Don Prout.)

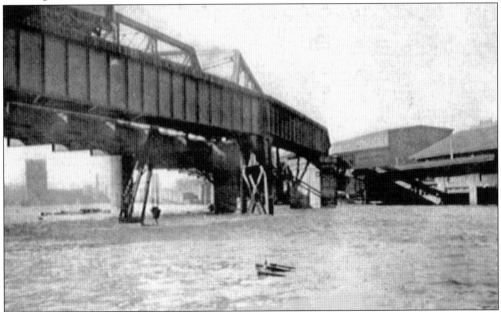

The main tracks of the railroad in 1907 were six feet underwater at the entrance to the Central Union depot on Second Street. Interruption of train service was more than an inconvenience to passengers. Supplies of coal and food were cut off, adding additional misery to citizens. Way stations in outlying areas were used as temporary terminals as the main depots were abandoned. (Courtesy of Don Prout.)

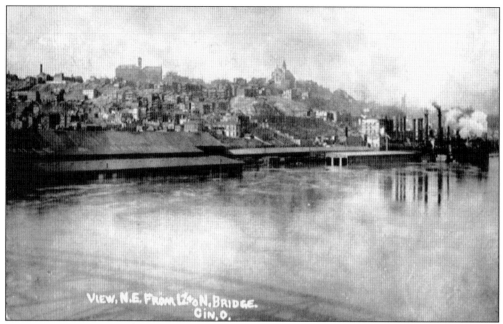

At the foot of Mount Adams, the L&N depot is underwater. On the far left are the chimneys that belong to the waterworks. Leaf tobacco warehouses fronted the river, and they quickly cancelled all their auctions. It was estimated that the January 1907 flood caused a property loss of $2 million and a $7 million loss to businesses. (Courtesy of Don Prout.)

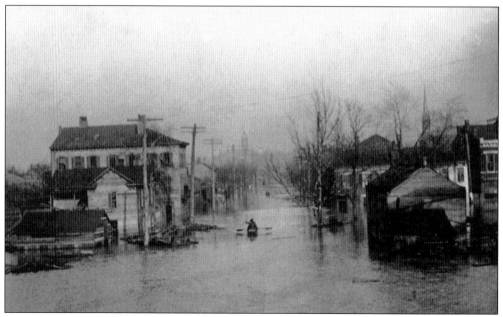

In those areas prone to frequent flooding, small boats were stored in attics. The narrow johnboats passed through a window, and the residents could paddle away to find shelter and food. Others, trapped in upper stories, ran out of food and fuel or did not have a place to burn the fuel. Johnboats were frequently rented at exorbitant costs, and during this flood police officers seized all boats for relief purposes. (Courtesy of Don Prout.)

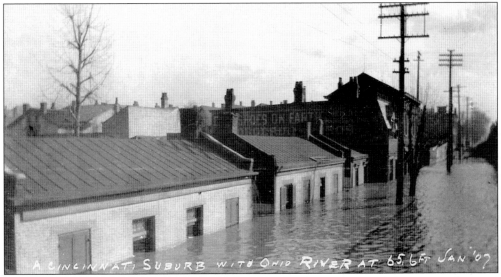

Cincinnati's Municipal Relief Committee considered requests that the city help to repair damaged houses. Mayor Edward Dempsey said that the city could no more restore a house from a flood than from a fire; its duty stopped with immediate relief for refugees. The mayor urged the building of a stone or concrete flood wall along the riverfront rather than a proposed raising of the streets to a grade of 65 feet in areas prone to flooding. (Courtesy of Don Prout.)

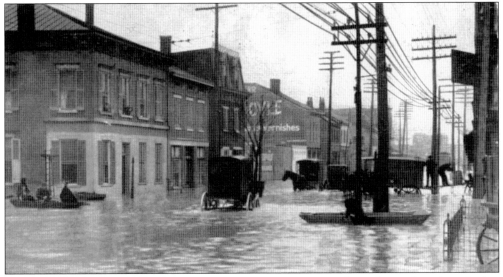

The Mill Creek flooded Spring Grove Avenue in January 1907 from the stockyards to Spring Grove Cemetery. Streetcars were stopped by the floods at the Mill Creek bridge and at the Colerain Avenue bridge. For the first time, elevated high-water streetcars were used. Crowds gathered along the bridges to watch trees, furniture, sheds, barrels, and small houses float away. In places, the Mill Creek spilled four miles out of its banks.

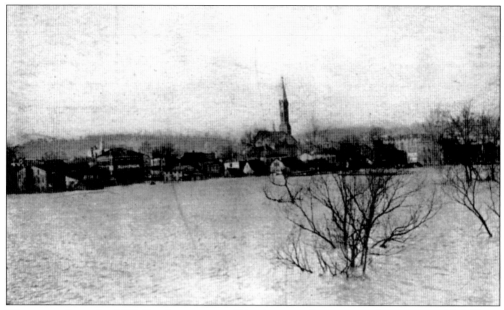

The water from the Mill Creek rose so swiftly that people were caught unaware. Neighbors helped each other carry possessions to higher locations. Household goods were pulled outside in the rain awaiting relatives or friends to come to the rescue. As long as the water did not cover the wheels, carts were piled high and moved families to other locations. Chase and Garfield schools were turned into emergency shelters.

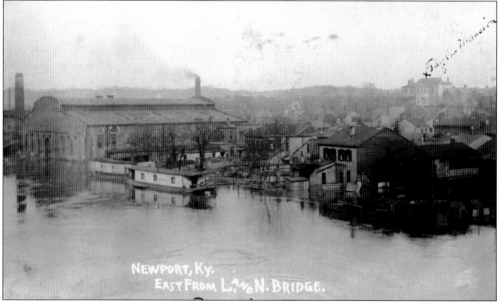

The X marks the location of General Taylor's Newport mansion. This east-facing view is from the L&N bridge. The high water closed the Newport waterworks pumping station and the gasworks. Displaced families with the possessions that they could carry were housed in the old Fourth Street School, the Newport Armory, city hall, and the basement of the courthouse. Police officers in boats patrolled the submerged areas. At the height of the 1907 flood, 50 city blocks were underwater.

This view of Jerry's Palace with the Fourth Street bridge in the background shows Covington awash. Shoreline houses were lashed to trees, and wood from lumberyards was rafted and moored to trees and strong buildings. The Licking River rose slowly, and a steady stream of wagons, carts, and moving vans worked during the night.

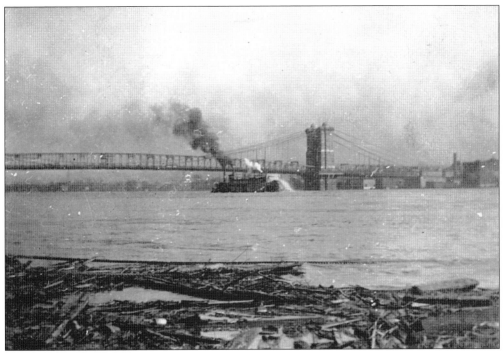

Just after the January 1907 flood was almost cleaned up, another flood struck (63 feet) on March 14–18. Passing under the Suspension Bridge during high water was the *Belle of Louisville*, which had hinged chimneys that could be thrown back to the level of the roof of the pilot house. A mail packet, it left port at 5:00 p.m. on March 16, 1907, the last vessel out before the port was closed for the duration of the flood.

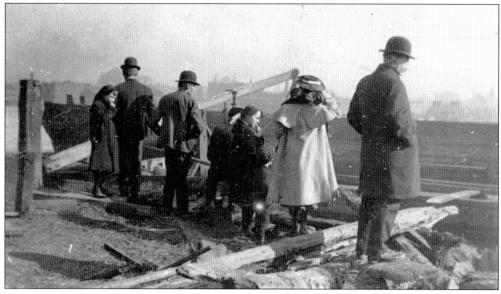

Crowds turned out to watch the flood on Sunday, March 17, when the temperatures soared to an unseasonable 70 degrees. Thousands of sightseers stood at Second and Broadway Streets, where there was a panoramic view of the shoreline. In the flooded West End, skiff owners made some money rowing sightseers to view flooded factories.

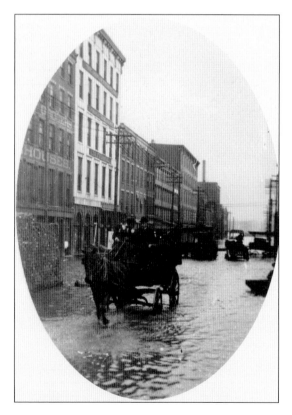

This view is from Walnut Street looking south to Second Street. During a four-day period 7.2 inches of rain fell. High-water streetcars were again in use, and low areas such as Spring Grove Avenue flooded at 57 feet. The area between Knowlton's Corner, Spring Grove Avenue, and Colerain Avenue was transformed into a three-mile lake. When the water receded, Springfield Pike, Reading Road, and Paddock Road were covered in waist-deep mud.

The Eighth Street viaduct was undermined by the floodwaters; a 120-foot section of the span collapsed on March 17, 1907. It lay in 28 feet of water along with split water and gas feeder mains and trolley, electric, telephone, and telegraph lines that snapped when the span collapsed. The steel structure shuddered, a geyser of water shot up from the soil at its eastern edge; the dirt there had a honeycombed appearance just before the section collapsed. It created an 18-foot wave that struck the opposite shore and went into the surrounding streets for two blocks. No one was injured. Streetcar men approaching the bridge noticed a vibration and stopped their cars in either direction. The embankment of filled ground upon which the bridge rested had been undermined by each of the 1907 floods. The fill had been taken from the old Chester Park racing track and mixed with sand and gravel, making a very porous mixture. The water main was laid on the fill, rather than resting on solid ground. Six pedestals on which the piers rested were swept away. Each pedestal was attached to 16 piles, which had been driven to a depth of 30 feet. The pilings were also gone.

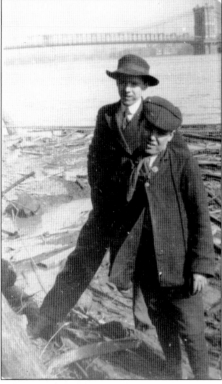

Walking among the driftwood and debris are sightseers and scavengers. Large numbers turned out at Spring Grove Cemetery, where low places were turned into lakes, and monuments were toppled and submerged. Workers, unemployed due to the floods, were hired to move furniture and merchandise. Lackmann Brewery and other businesses donated wagons for moving residents away from the flooded neighborhoods.

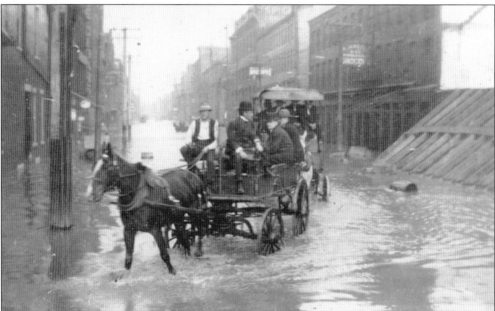

Here is Second Street looking east from Walnut Street. From Broadway Street to Main Street basements were inundated with high water and sewer line backups. Wharf boats were kept busy with merchants rushing to get their shipments aboard before the river traffic was cut off. Stables owned by the coal yards that lay in the path of the rising waters were emptied of horses, creating a shortage of stalls in higher parts of the city.

Near Bromley, John Hall's fish farm was submerged, releasing 10 million goldfish. Perhaps this is the source of goldfish still found living in the Ohio River. Covington and Newport were patrolled by policemen in boats. Mail, fire, and police call boxes were collected to protect them from high water. Flatboats built for rescue in January were readied and once again used. In Newport boating parties were common to tour the streets. One enterprising saloon owner, having been displaced from his bar by the flood, set up a temporary bar on a scow, announcing plenty of "wet goods" for sale. Those residents trapped on the second floor of their houses and without boats complained of their lack of coal, water, and food. Relief boats would paddle underneath their windows, and people used ropes to pull up supplies. The Licking River undermined its Covington side, causing landslides and endangering houses.

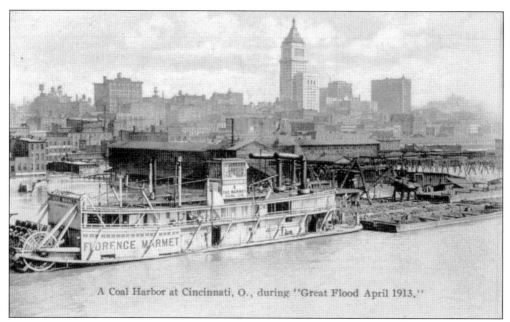

A Coal Harbor at Cincinnati, O., during "Great Flood April 1913."

The flood of January 1913 crested at 62.5 feet on the 14th. The *Florence Marmet* is towing a coal barge. To the left are Water and Front Streets, whose warehouses are already underwater. The flooding returned in March and April of that year with a high-water mark of 69.9 feet on April 1, 1913. It rained for five days, accumulating from 6 to 11 inches throughout the entire state.

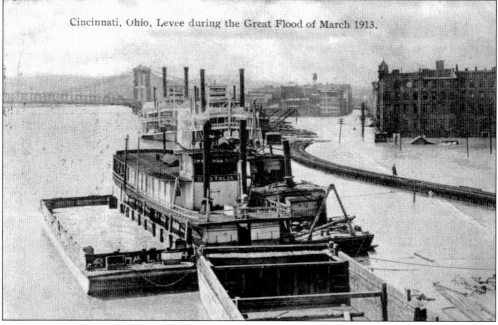

Cincinnati, Ohio, Levee during the Great Flood of March 1913.

To the right of the steamboat, the railroad tracks are not yet underwater, but the rail depot has flooded. Several steamboats are moored at the levee. This was more than a local flood. New York, Pennsylvania, Indiana, Kentucky, Ohio, and states further south were all flooded. Train traffic was at a standstill.

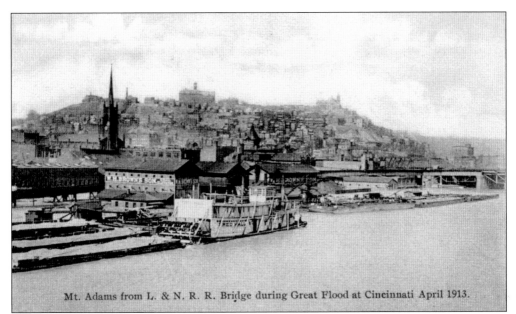

Mt. Adams from L. & N. R. R. Bridge during Great Flood at Cincinnati April 1913.

Steamboats are docked upriver near the waterworks plant at the foot of Mount Adams, as seen from the L&N bridge. The waterworks plant flooded, and operations were shifted to a new location upriver in California outside of downtown. It would not be compromised until a 75-foot flood stage was reached. Telegraph lines were down as the embankments, which supported the railroad tracks, crumbled.

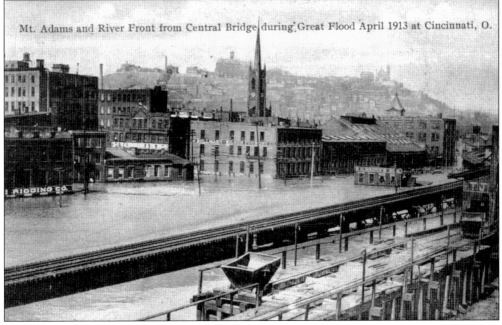

Mt. Adams and River Front from Central Bridge during Great Flood April 1913 at Cincinnati, O.

The railroad tracks here are still elevated above Cincinnati and the water. Cincinnati was fortunate that its main railroad bridges were not swept away, as the bridges in Loveland, Elizabethtown, Addyson, Milford, and Harrison, as well as Lawrenceburg, Indiana, had been.

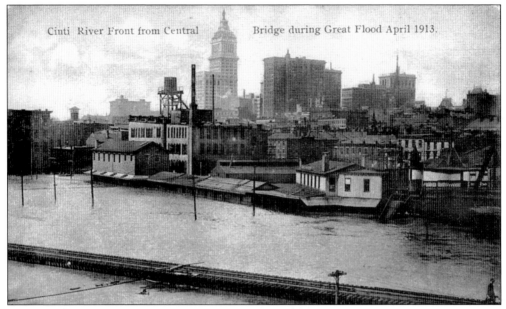

Cinti River Front from Central Bridge during Great Flood April 1913.

The view seen on this postcard was photographed on April 1, 1913, from the Central Bridge. This was the city's warehouse district. Businessmen worked around the clock for days trying to move their merchandise to different locations for the second time that year. The inconvenience, cost, and losses prompted merchants to move away from the riverfront as outlying areas became more accessible by rail and road.

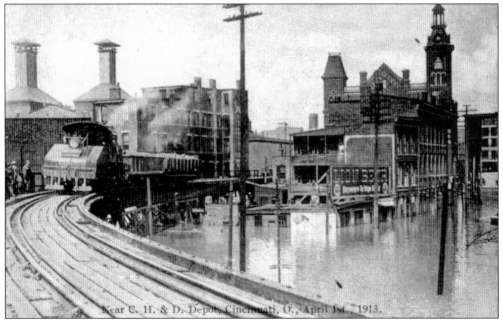

Near C. H. & D. Depot, Cincinnati, O., April 1st, 1913.

The depot (right) is near the Cincinnati, Hamilton and Dayton train tracks. The first information about the levees in Dayton failing and that the city was completely cut off came into the Cincinnati, Hamilton and Dayton depot via a dispatch from Pennsylvania. Then all communication stopped, as part of the telegraph system succumbed to the waters. Western Union said that the telegraph system was at its worst point since being strung. The billboard advertises Lion Beer.

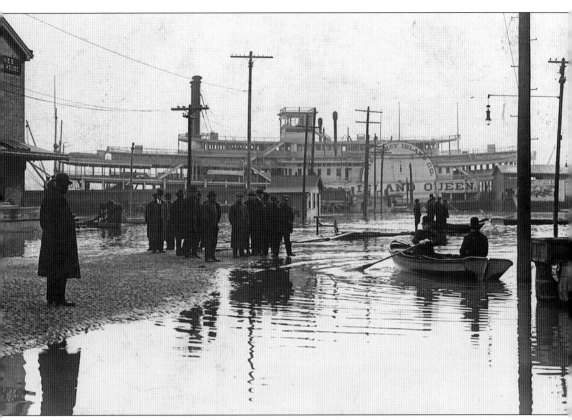

The *Island Queen* is moored at the public landing. Coney Island, nine miles upriver, was underwater, so the steamboat stayed here at its wharf. The river flood stage of 69.9 feet had been reached, and all river traffic was halted. The Ohio River rose 21 feet in 24 hours and flowed at a speed of six miles per hour. This is the first steamer of the name, built locally in the East End in 1895. The *Island Queen* was inaugurated on May 31, 1896, and cost $80,000 to construct. Its five decks could accommodate 3,000 passengers. It was replaced in 1925 by a larger steamboat, which made five round-trips daily from the downtown Coney Island wharf to the amusement park. This second boat lasted until September 1947, when it burned at a wharf in Pittsburgh. Before the *Island Queen* there were other excursion boats. In 1906, the *Island Princess* joined the *Island Queen*, transporting an additional 1,000 park customers. All were at the mercy of the river, because, during the summer months, the Ohio River could become too shallow for boat traffic while at the other extreme there were winter floods and ice gorges.

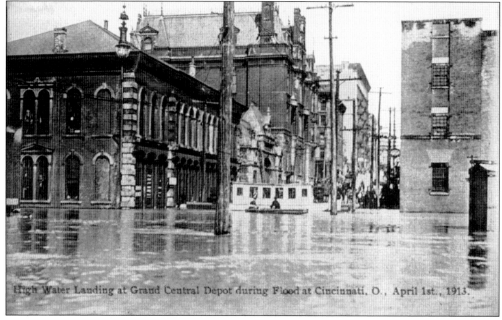

High Water Landing at Grand Central Depot during Flood at Cincinnati, O., April 1st., 1913.

This is a close-up of the Grand Central Rail Road Depot. In the center of the picture, two people are rowing a boat while crowds wait on the dry pavement further up the block. The railroad problems of 1913 were the worst since the tracks had been laid in Cincinnati.

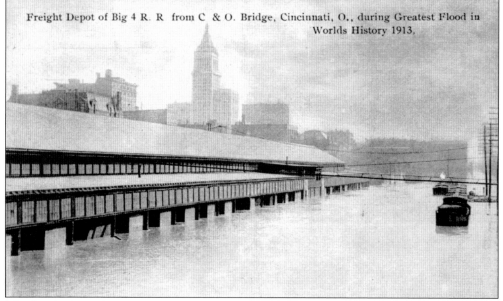

Freight Depot of Big 4 R. R. from C & O. Bridge, Cincinnati, O., during Greatest Flood in Worlds History 1913.

The freight depot for the Big Four Railroad (Cincinnati, Chicago, Cleveland, and St. Louis) is underwater, as seen from the Chesapeake and Ohio bridge. Food prices rose as farm products could not be brought into Cincinnati, and foodstuffs at the depots were destroyed. Railroad cars of potatoes marked for Cincinnati were seized by small towns along the tracks desperate for food. Potato prices here tripled. Butter and eggs were scarce. However, there was plenty of cabbage with 500 tons locally available.

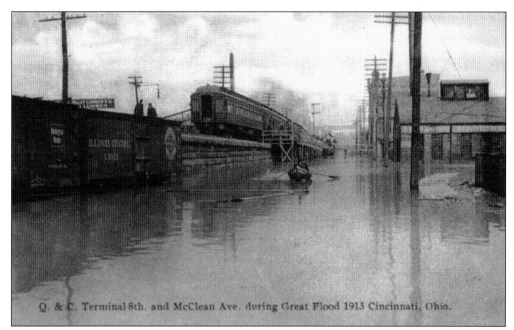

Q. & C. Terminal 8th. and McClean Ave. during Great Flood 1913 Cincinnati, Ohio.

On Eighth Street and McClean Avenue, the Queen and Crescent terminal is underwater. This section of track is elevated enough to keep part of the train above the water. Two men are observing the flood from the tracks while a rowboat travels parallel in the flood. Rain in Cincinnati fell 5.56 inches in 50 hours.

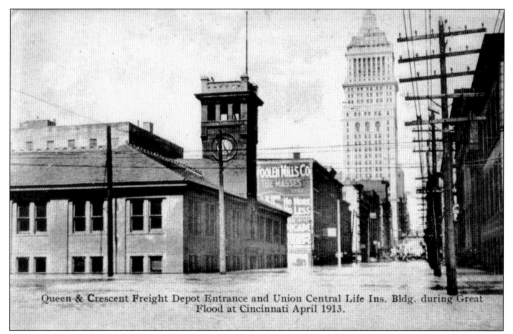

Queen & Crescent Freight Depot Entrance and Union Central Life Ins. Bldg. during Great Flood at Cincinnati April 1913.

The Queen and Crescent depot entrance fronting Vine Street is flooded to its second story. The newly built Union Central Life Insurance building on Fourth Street is in the background. The weather bureau had an automatic flood gauge on the Suspension Bridge, but it could not get warnings to all businesses that would be affected. The telephone lines were already down.

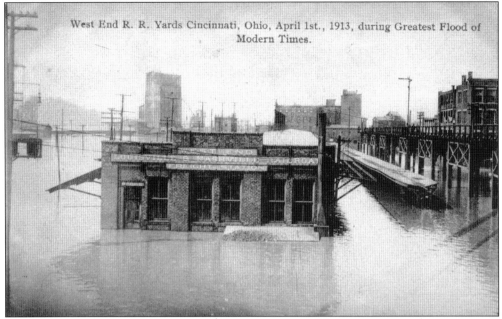

West End R. R. Yards Cincinnati, Ohio, April 1st., 1913, during Greatest Flood of Modern Times.

In the West End, the Louisville and Nashville Railroad freight depot and tracks are underwater. No trains were moving in Ohio, hindering relief efforts. Cincinnati's suffering and damage were less serious than that experienced by Hamilton and Dayton.

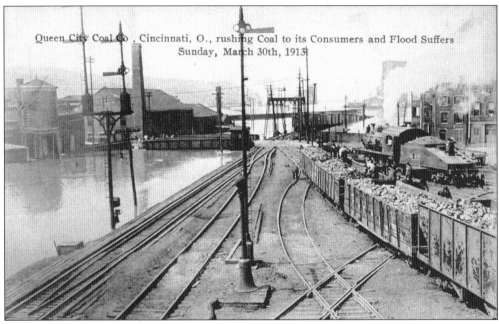

Queen City Coal Co , Cincinnati, O., rushing Coal to its Consumers and Flood Suffers Sunday, March 30th, 1913

The Queen City Coal Company rushed to deliver coal to its customers and others. Fuel was in demand and, for a time, rationed while the supplies were very low due to flooding that crippled both the railroads and river barges. Whenever possible, trains did not stop unless the tracks were missing or floodwaters were so high as to put out the flames in the engine's firebox.

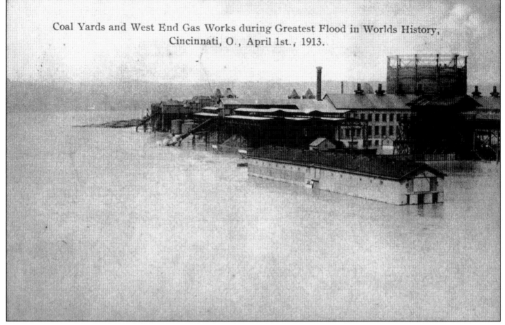

Coal Yards and West End Gas Works during Greatest Flood in Worlds History, Cincinnati, O., April 1st, 1913.

Along the riverfront in the West End was the gasworks that supplied natural gas to Cincinnati. "Gas Island" held the steel tanks that contained the natural gas of the Union Gas and Electric Company. The coal yards are in the center of the postcard. The Ohio River here was 21 feet higher than at Maysville, Kentucky.

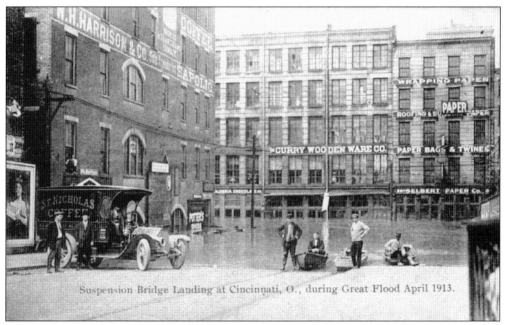

Suspension Bridge Landing at Cincinnati, O., during Great Flood April 1913.

The landing at the Cincinnati foot of the Suspension Bridge is surrounded by the flood. The automobile on the left advertises St. Nicholas Coffee. Behind the youths with their rowboats are the Curry Wooden Ware Company and the Selbert Paper Company.

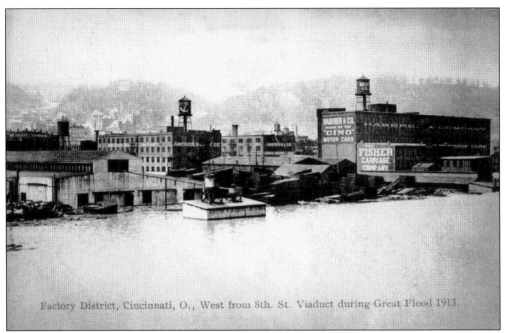

Factory District, Cincinnati, O., West from 8th. St. Viaduct during Great Flood 1913.

On the right is the Fisher Carriage Company, advertising "Cino" Motor Cars. This is the factory district west of the Eighth Street viaduct.

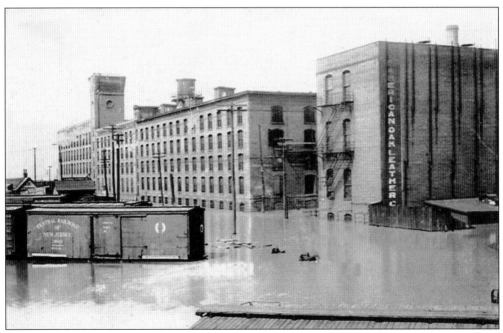

The Hall Lumber Company (left) and the American Oak Leather Company are flooded along with the railroad they depended on for moving merchandise and supplies. This is Kenner and Dalton Avenues.

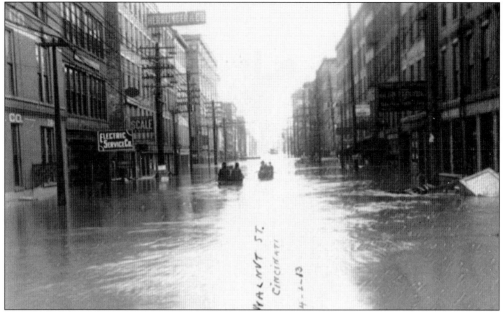

Walnut Street resembled a large canal on April 2, 1913. Electric Service Company and Herrlinger and Company are on the left. The city authorized the confiscation of boats if a satisfactory rental agreement could not be reached between the owners and the citizens relief committee. The boats at Burnet Woods and Lincoln Park were purchased for $15 apiece from the concessionaires. (Courtesy of Don Prout.)

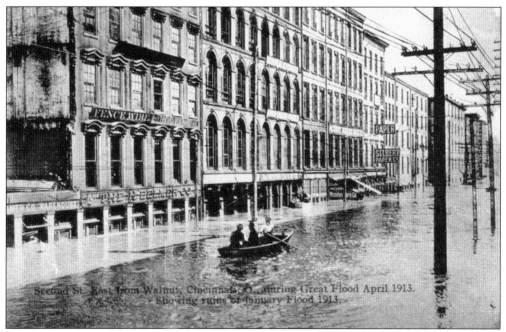

Photographed east from Walnut Street, this is Second Street. The front of the Selbert Paper Company is to the right of telephone poles. The building on the near left admonishes to "Fence with Iron."

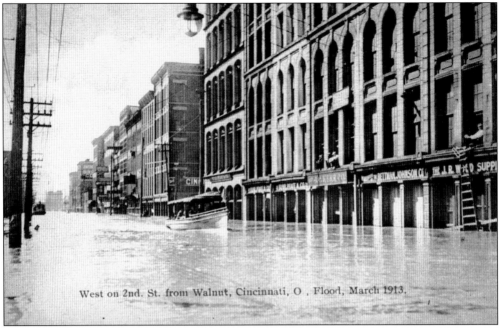

West on 2nd. St. from Walnut, Cincinnati, O., Flood, March 1913.

This is Second Street, photographed west from Walnut Street. Several men are leaning from the second-story windows, while the man on the far right is lowering a collapsible ladder. Possibly the boat is bringing him supplies.

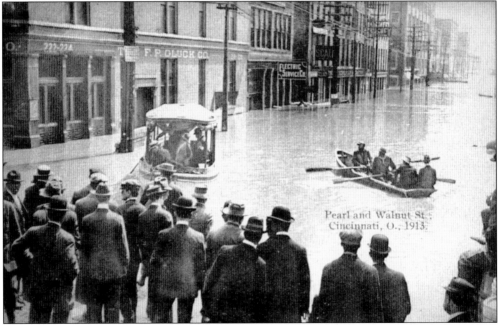

Pearl and Walnut St., Cincinnati, O., 1913.

Pearl Street was located between Second and Third Streets and terminated to the west at the Grand Central Depot. This is the corner of Pearl and Walnut Streets. The crowd here is awaiting their turn for boat transportation.

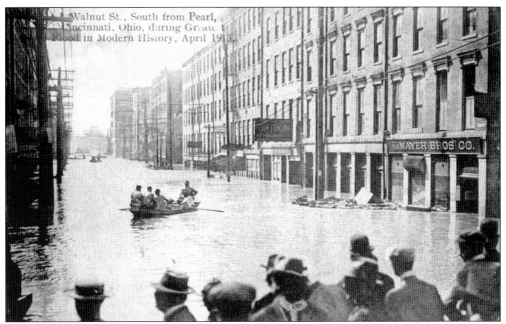

This stretch of Walnut Street shows the conditions south from Pearl Street. On April 1, 1913, the *Cincinnati Times-Star* reported, "Roustabouts, all Sunday afternoon poled and rowed a long johnboat filled with supplies from Pearl street on Sycamore, to the boat tied up at the wharf of the Greene line of steamers . . . the rousties worked with a vim and they were the men who put the food into hungry mouths, and blankets over chilled limbs in stricken Lawrenceburg."

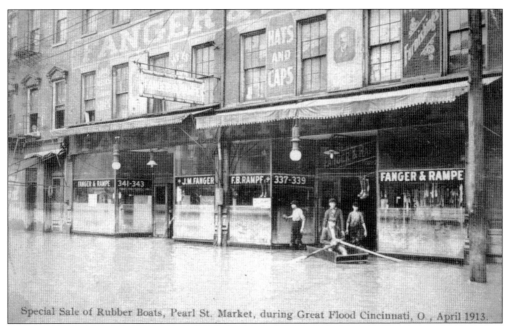

Franger and Rampe, known as the Pearl Street Market, had a special sale of rubber boats during the flood. Potter's advertised rubber boots, while the Ohio Rubber Company advertised rubber hose for cleaning up the flood's aftermath.

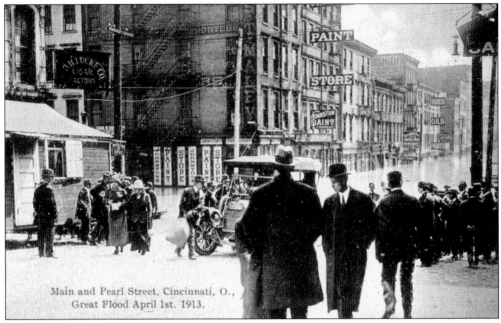

Main and Pearl Street, Cincinnati, O.,
Great Flood April 1st. 1913.

Just north of the R. F. Johnston Paint Company store, at the corner of Main and Pearl Streets, the street sloped upward, slowing the crawl of the floodwaters.

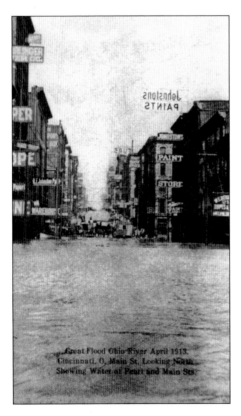

Great Flood Ohio River April 1913.
Cincinnati, O. Main St. Looking North.
Showing Water at Pearl and Main Sts.

The Johnston paint store covered a city block (right). Its warehouse was located across the street. This angle is of Main Street looking north toward a line of waiting vehicles that spanned the road.

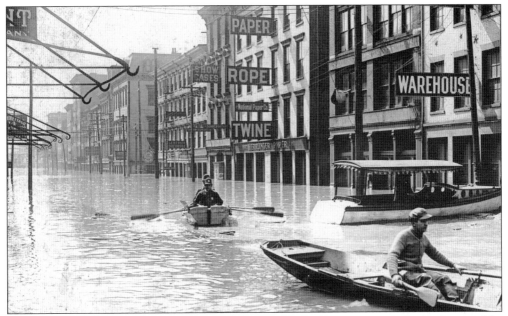

This is a close-up of boats in front of the R. F. Johnston Paint warehouse. The back of some of the Johnston Paint postcards have the following message: "The Mail, Telegraph and Transportation facilities of Cincinnati and vicinity have been greatly impaired by floods since March 25th. If there is an apparent delay in writing you, it is entirely due to this course and not to inattention on our part."

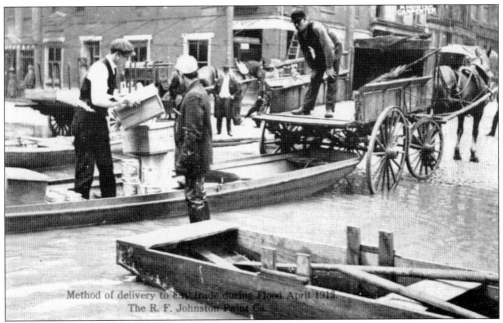

The R. F. Johnston Paint Company still was able to fill orders by boat and then transference to horse cart. The company used many views of its employees at work during the flood for advertising purposes.

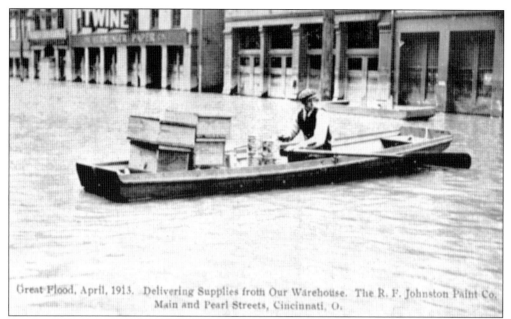

Great Flood, April, 1913. Delivering Supplies from Our Warehouse. The R. F. Johnston Paint Co. Main and Pearl Streets, Cincinnati, O.

The floodwaters appear to have receded because the high-water mark can be clearly seen on the background buildings. All boats were pressed into service. In the basement of city hall, carpenters built 20 cypress boats, holding 10 people each, for emergency relief. They were manned by policemen. After the flood, the boats were to be stored in city hall for use in the next emergency.

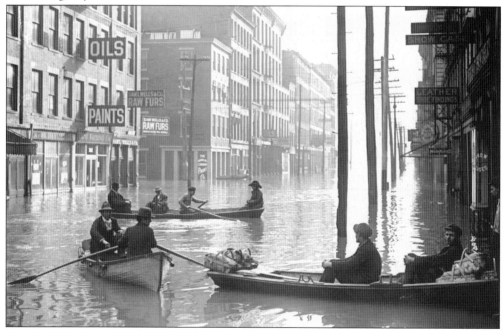

Relief workers delivered supplies. The foreground boat has two baskets in the bow. Three buildings were filled with food and clothing donations. The National Biscuit Company donated biscuits and thousands of loaves of bread to Cincinnati and Dayton. To the left are the Bird Varnish Company, Mamolith Carbon Paint Company, and Sam Wells, dealer in raw furs.

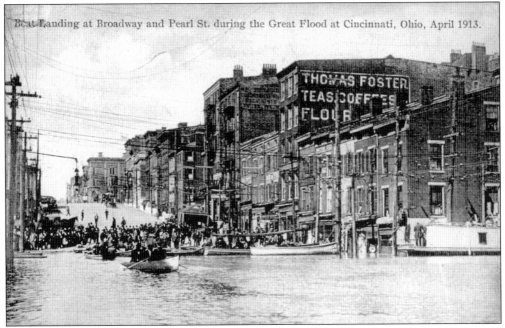

Boat Landing at Broadway and Pearl St. during the Great Flood at Cincinnati, Ohio, April 1913.

Broadway Street (running north and south) rose above Pearl Street (running east and west). Their intersection became a convenient boat landing. Police banned all motorboats without a specific purpose from operating in flooded areas.

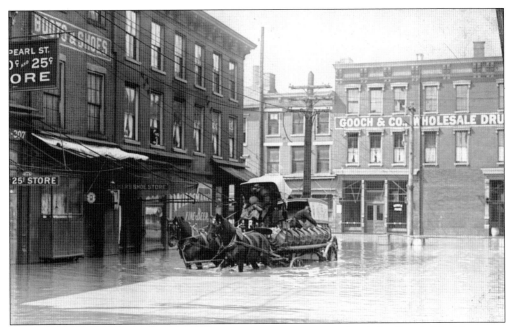

Pearl Street 10¢ and 25¢ store is being passed by a wagon. Another is loading behind it, across from Gooch and Company Wholesale Drugs. Wagonloads of food, supplies, and clothing were donated and distributed, because Cincinnati provided care not only for its own citizens, but those fleeing the flood in Hamilton and Dayton as well.

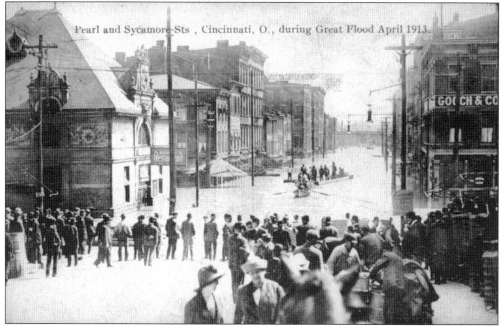

Pearl and Sycamore Sts., Cincinnati, O., during Great Flood April 1913.

Around the corner at Pearl and Sycamore Streets, the Gooch and Company building is on the far right. The ornate building on the left is a restaurant. Thousands of people were temporarily out of work, some without a home. A total of 18 relief stations were set up across the city. Schools were used for temporary housing, as well as the Union Bethel, Pearl Street Market House, and the Salvation Army Citadel.

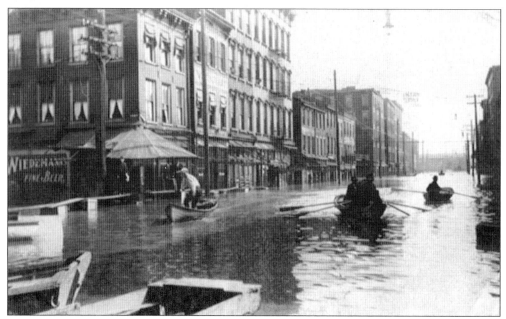

Wiedemann's Fine Beer is advertised along the side of the Vulcan Supply building at 120 Sycamore Street. On the left is a makeshift boardwalk of planks atop crates.

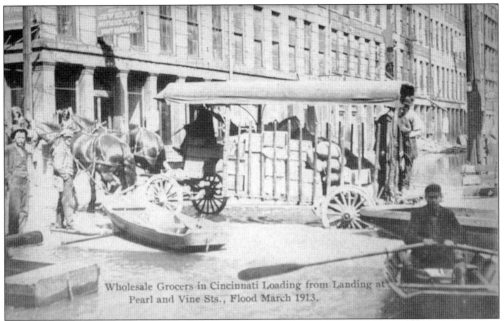

Wholesale Grocers in Cincinnati Loading from Landing at
Pearl and Vine Sts., Flood March 1913.

Wholesale grocers are loading from the landing at Pearl and Vine Streets. The stables of the Cincinnati Transfer Company were flooded but not before several hundred horses and many wagons were moved to higher ground.

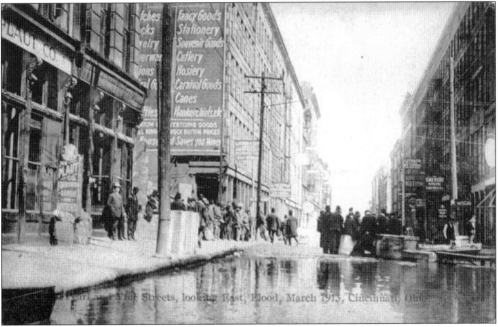

This is another view of the flood from Pearl and Vine Streets, looking east. The cause for the flood, according to a civil engineer quoted in the *Cincinnati Times-Star* newspaper, was deforestation. Years later, the heavy flooding was attributed to at least 80 percent of the soil reaching saturation, thus creating extraordinary runoff.

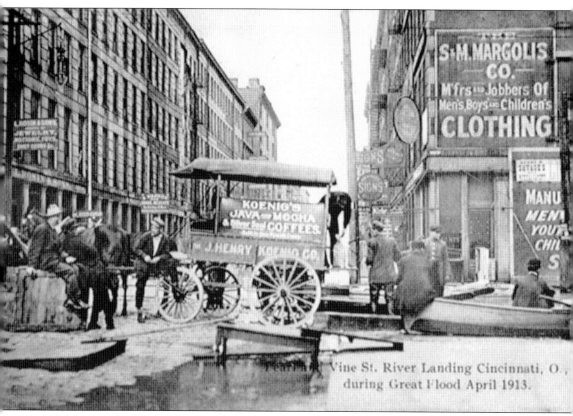

Vine St. River Landing Cincinnati, O.,
during Great Flood April 1913.

This postcard of the temporary landing at Pearl and Vine Street shows many merchants. To the left is L. Rosin and Sons, sellers of jewelry, notions, and toys. The wagon in the middle advertises J. Henry Koenig's Java and Mocha and Silver Seal Coffees. On the right is the S&M Margolis Company, clothing manufacturers. Behind Margolis was a sign maker and painter. In the foreground are short wooden gangplanks. On Thursday, March 27, 1913, Cincinnati mayor Henry T. Hunt released to the press, "Cincinnati is exhausting herself in attempting to feed 70,000 starving people of the Miami valley. We must have financial and material assistance. Every city should appoint a relief committee to raise money and purchase supplies and forward both to us. Five hundred thousand dollars would not be enough to care for the situation. I will be responsible for the proper distribution of supplies and expenditure of money. This city is doing its utmost and the need is greater than it can supply. Let every generous American aid us as we would aid him if he were in our condition." (Courtesy of Don Prout.)

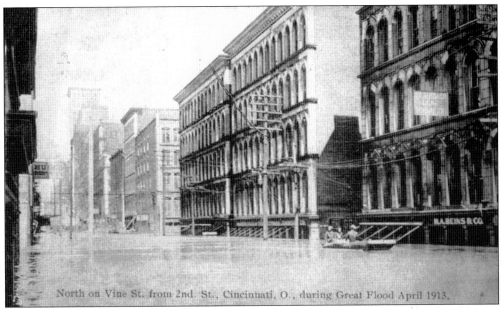

North on Vine St. from 2nd. St., Cincinnati, O., during Great Flood April 1913.

Taken from Second Street, the Union Central Life Insurance skyscraper is the background of this image. The marble building was designed by Cass Gilbert, who also designed New York's Woolworth building. The unusual columned and pyramid-shaped top was Gilbert's interpretation of the tomb of Mausolus at Halicarnassus, one of the Seven Wonders of the Ancient World. When it was completed in 1913, it was the tallest building outside of New York City and was the fifth tallest in the world.

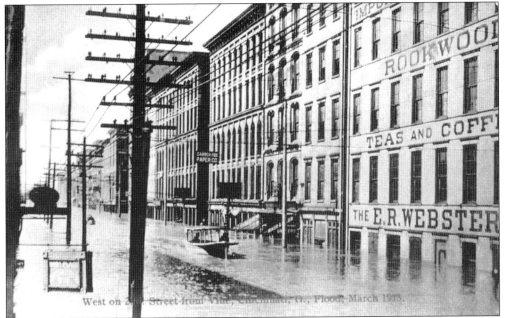

West on 2nd Street from Vine, Cincinnati, O., Flood, March 1913.

This image is of the west of Second Street taken from Vine Street. On to the right is E. R. Webster, importer of Rookwood brand teas and coffee. To help distribute relief, Cincinnati was divided into three sections. The food baskets or clothing bundles would be distributed to the chairman of each section, and then his committee would be responsible for further allotment.

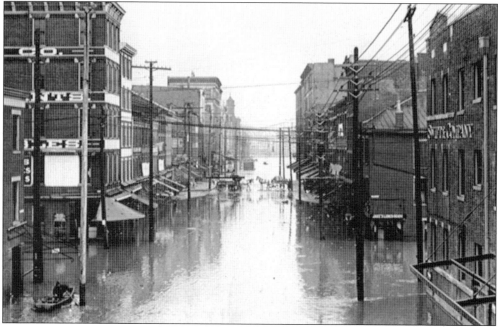

Two wagons stand on the only shallow flooded area of Main and Front Streets. In the background is the Suspension Bridge. Throughout the history of Cincinnati flooding, the Suspension Bridge has remained open, even in 1937. (Courtesy of Don Prout.)

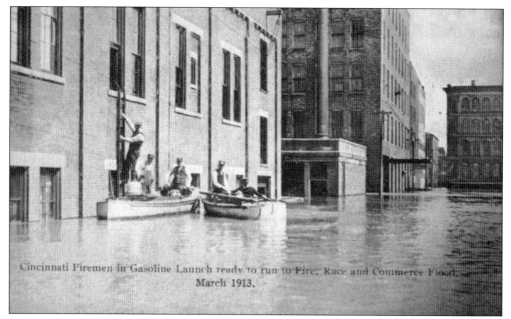

A Cincinnati fireman is climbing down a ladder into a gasoline launch at Race and Commerce Streets (between Front and Second Streets). The Big Four Freight depot on Pearl Street caught fire when a large container of gasoline floated near the depot and ignited. Burning fuel was thrown over the building, catching the walls on fire. Most of the building was saved by firemen wading out with their hoses. Gas was turned off in flooded areas as a precaution.

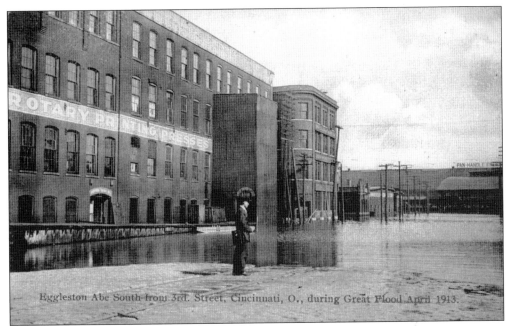

Eggleston Ave South from 3rd. Street, Cincinnati, O., during Great Flood April 1913.

Eggleston Avenue, south of Third Street, was heavily flooded. There was no garbage or ash pick up for the duration of the flood in the affected area. The wagons that would have been used for weekly collections were diverted to moving families and their possessions from low-lying areas.

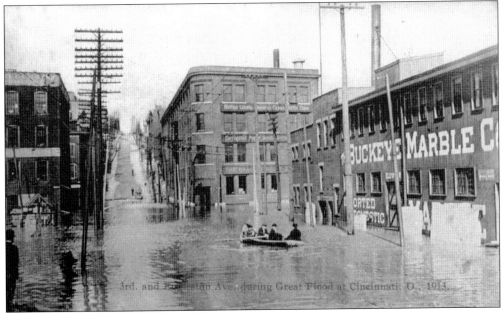

3rd. and Eggleston Ave. during Great Flood at Cincinnati, O., 1913.

Eggleston Avenue, from Third Street looking north, was an industrial area. To the right is the Buckeye Marble Company, selling imported and domestic marble. Men were still moving stock as the waters flowed into the first floor of warehouses.

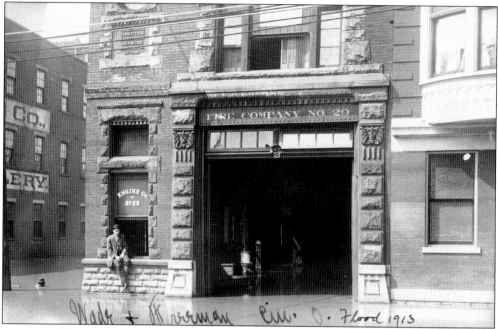

Cincinnati Fire Company No. 29 was on the corner of Wade and Freeman Avenues in Brighton. To the left of the firehouse wall, just the top of a fire hydrant can be seen.

There were few fatalities in Cincinnati due to the flood. In Venice, a small town on the Miami River, 32 died. An estimated 300 perished in Hamilton. Columbus reported 101 deaths. The statewide death toll was nearly 500. Milford, Loveland, Reading, Norwood, Cleves, Harrison, Miamitown, and New Baltimore are just a few of the towns surrounding Cincinnati that were heavily flooded and had fatalities. (Courtesy of Don Prout.)

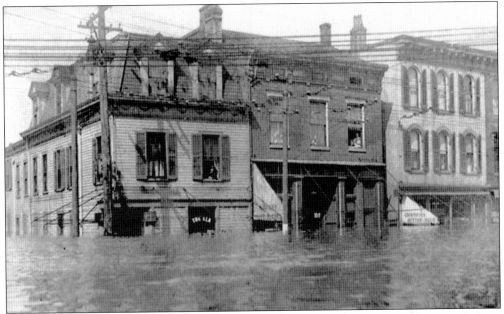

Residents of Northside's Knowlton's Corner are looking out from their second-story windows due to the flooding of the Mill Creek. These buildings are still standing. Cumminsville, Chester Park, Elmwood, and St. Bernard were also flooded. At Ivorydale the Procter and Gamble plant was closed down, its machinery for generating power flooded. Spring Grove Avenue was a lake, and all burials at Spring Grove Cemetery were halted. (Courtesy of Don Prout.)

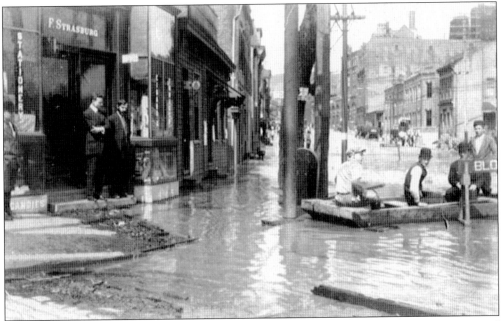

Men are standing on the top step of the P. Strasburg store, which sold candy, stationery, toys, and cigars, located at 1373 Harrison Avenue. Across the flooded Mill Creek Valley the West Side experienced difficulties with mail delivery. Mailmen carried sacks of mail on their backs from the main post office to the community for delivery. (Courtesy of Don Prout.)

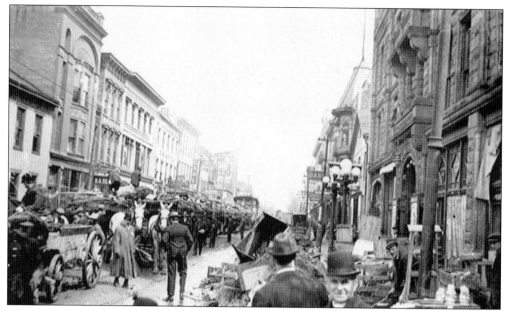

Wagons full of debris crowd a street after the flood receded at an unknown location. Aid was still distributed as people returned to their homes and shops. As in all the severe floods, some people lost everything and never recovered. (Courtesy of Don Prout.)

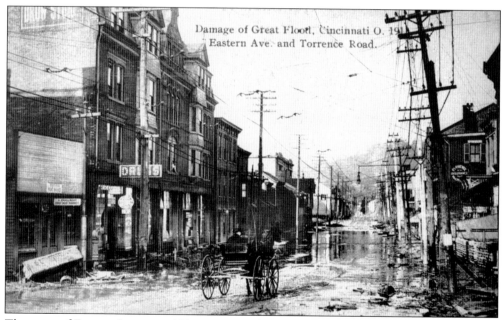

The scene of Eastern Avenue and Torrence Road cleanup was a common one. The hillsides of Torrence Road were in danger of slipping during the flood. The East End was described as "a gigantic custard pudding flecked with raisins," the raisins being the roofs of houses. Turkey Bottom was under 20 feet of water. Water lapped at the base of Mount Washington.

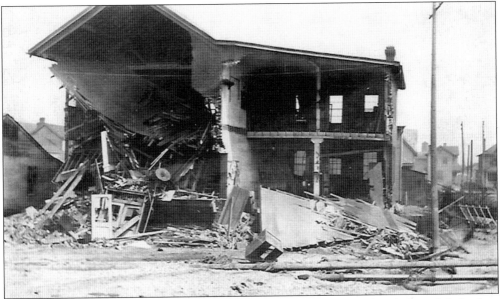

This building collapsed from the flood. The people lost everything they had, and their place of employment may have been gone too. As the waters rose animals and their owners clung to roofs or the branches of submerging trees.

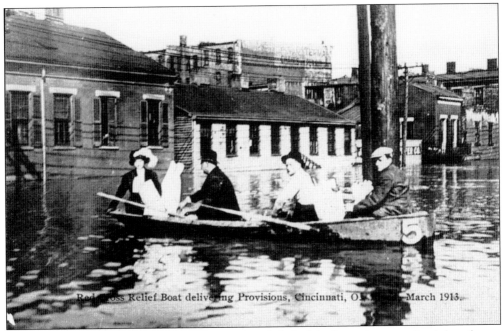

Red Cross Relief Boat delivering Provisions, Cincinnati, O.—March 1913.

The Red Cross delivered provisions to those stranded. Each basket or bag contained three loaves of bread, one pound of coffee, one pound of sugar, one pound of rice, one can of condensed milk, one can of sausage, one can of soup, one can of salmon, one can of sardines, one can of corn, a large can of baked beans, a piece of ham, potatoes, and candles. This was contributed by the U.S. government and was considered enough food to feed a family of 5 for three meals. Over 20,000 baskets were distributed.

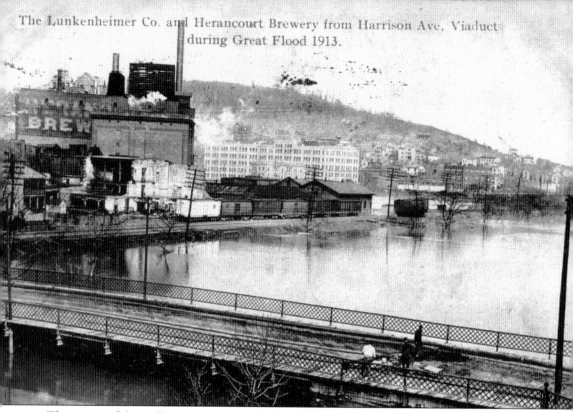

The Lunkenheimer Co. and Herancourt Brewery from Harrison Ave. Viaduct during Great Flood 1913.

The extent of the Mill Creek flooding can be seen here. In the foreground is the old Harrison Avenue viaduct. In the center is the Lunkenheimer Company. Herancourt Brewery is on the left. The Lunkenheimer Company moved to Fairmont in 1900, in part to avoid the flooding it had endured at its Eighth Street location. In Fairmont, the company sat next to the railroad and streetcars brought employees to work. The company was founded by Frederick Lunkenheimer, a German immigrant who arrived in New York in 1845. After working at various machine shops around the country, he came to Cincinnati and was employed by Miles Greenwood when he decided to open his own business. The business was first called the Cincinnati Brass Works and was located on Seventh Street, east of Main Street. He manufactured whistles for steamboats, valves, and gauge cocks. Frederick died in 1889 and his son Edmund took over the business. Edmund changed his surname to Lunken, against family wishes. During World War I, the company shifted its manufacturing materials from brass to bronze.

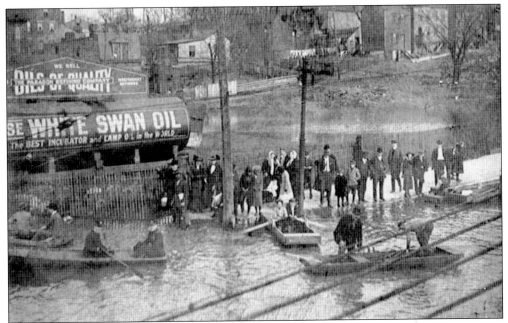

"White Swan Oil, the Best Incubator and Lamp Oil in the World, We Sell Oils of Quality, the Paragon Refining Company" is advertised on the side of this storage tank at the Baltimore and Ohio Railroad tracks in Northside. In the background is Colerain Avenue. In under an hour, four feet of water poured into the homes and businesses around Virginia and Colerain Avenues. The Runnymede bridge over the West Fork Creek collapsed, causing the creek to backup and spill into the streets at this location. (Courtesy of Don Prout.)

This is Norwood in the 1913 flood. Skiffs and johnboats came to the aid of those stranded. Any low land in the Ohio River valley was flooded. (Courtesy of Don Prout.)

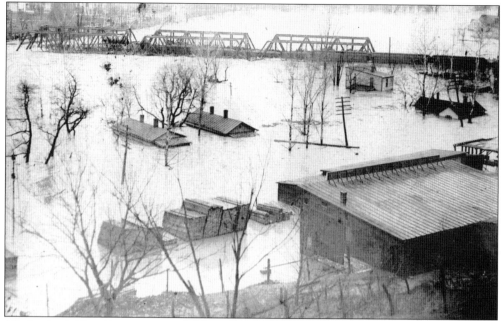

All that is visible of houses in Loveland are rooftops. All bridges were eventually washed away as houses, floating downriver, crashed into them. People crawled onto their roofs, calling for rescue, but the waters were too swift to make an attempt. The people, and their houses, swept on by. A covered bridge from upriver crashed against Loveland's iron wagon bridge, sinking it.

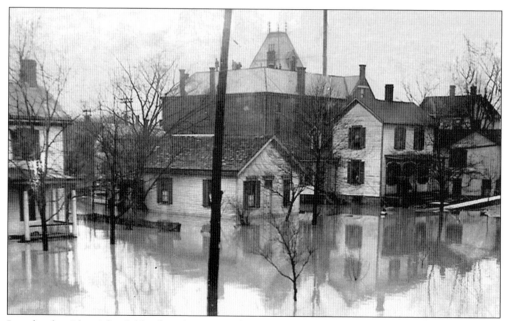

Loveland residential neighborhoods were without telephone service; there was no telegraph and no railroad. "The Island," an area of 75 summer cottages, was swept clean during the night of March 25, 1913, taking all phone lines with it. All communities south of Milford were therefore without communication. But as bad as the property damage was, not a life in Loveland was lost. (Courtesy of Don Prout.)

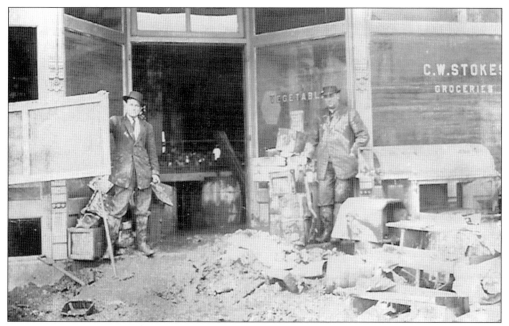

The grocery of C. W. Stokes is standing in water and mud after the floodwaters receded in Loveland. Spence's drugstore, E. B. Gatch's general store and post office, Jacob Brown's general store, the bank, Spark's hardware, Casey's grocery store, Casey's millinery shop, and Rieber's drugstore were all casualties of nine feet of floodwater. The river ran through the stores as fast as four feet in three minutes, tossing merchandise, washing it away, and finally leaving behind a coating of sludge and debris. (Courtesy of Don Prout.)

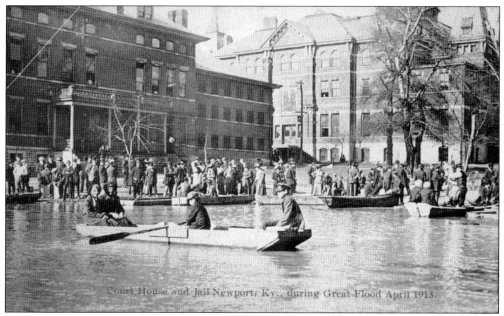

The area in front of the Newport, Kentucky, jail and Campbell County courthouse served as a landing, as seen from Fifth Street. Newport and Covington were flooded from both the Ohio and Licking Rivers.

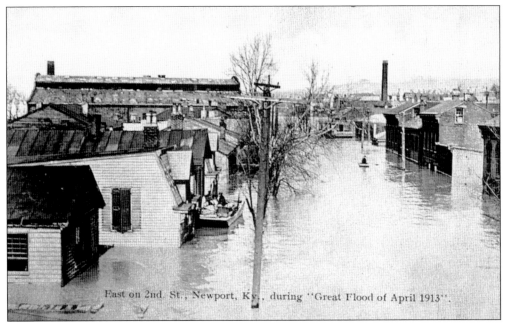

East on 2nd. St., Newport, Ky., during "Great Flood of April 1913".

This image shows the view looking east on Second Street in Newport. Newport had a steam-driven power plant on Eleventh Street that produced electricity for lighting and powering the streetcars for Covington and Newport. This station was shut down as the waters rose. Without streetcars, the suburbs of Fort Thomas, Southgate, Fort Mitchell, and Rosedale were handicapped, but every bit of steam available was put into keeping the lights on.

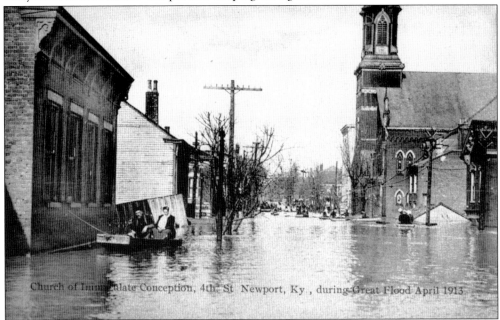

Church of Immaculate Conception, 4th St Newport, Ky., during Great Flood April 1913

On the right is the Church of the Immaculate Conception on Fourth Street in Newport. By March 31, there were 90 blocks of Newport inundated by water. Bishop C. P. Mayes of the Catholic diocese of Covington requested a special collection to be made in all churches to help the tristate flood victims.

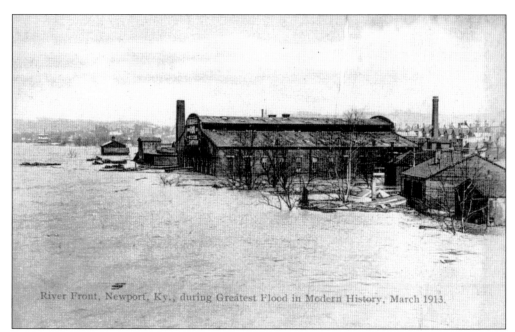

River Front, Newport, Ky., during Greatest Flood in Modern History, March 1913.

To get to work, Newport's citizens would try to cross the Suspension Bridge into Cincinnati by walking on planks set over trestles on the bridge floor. Some were able to go across, others turned back. As long as the streetcars operated they used the Central Bridge to traverse the raging Ohio River.

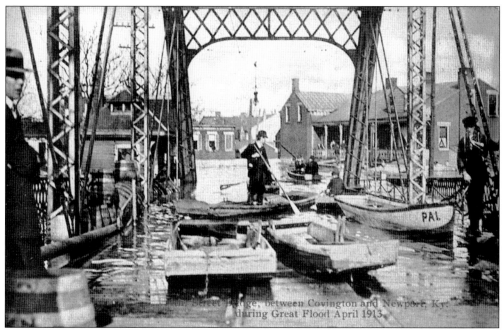

Street Bridge, between Covington and Newport, Ky., during Great Flood April 1913.

The Fourth Street bridge linking Covington and Newport over the Licking River was underwater. The strong currents of the floodwaters undermined the river's banks, and houses tumbled into the water.

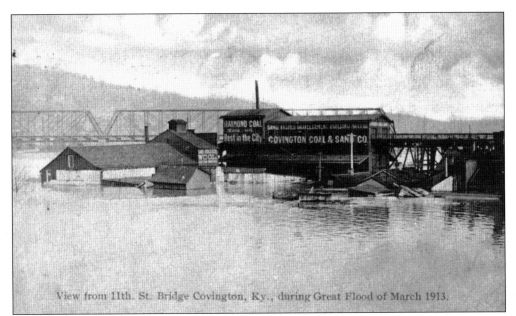

View from 11th. St. Bridge Covington, Ky., during Great Flood of March 1913.

The Covington Coal and Sand Company, selling Diamond Coal, stood in the flood plain. This view was photographed from the Eleventh Street bridge in Covington. Wagons were borrowed from Wiedemann Brewery and other businesses to move people and furnishings away from the flood. The Kentucky communities of Bromley and Ludlow were temporarily islands. The Ludlow Lagoon loaned its 25 boats to help both communities.

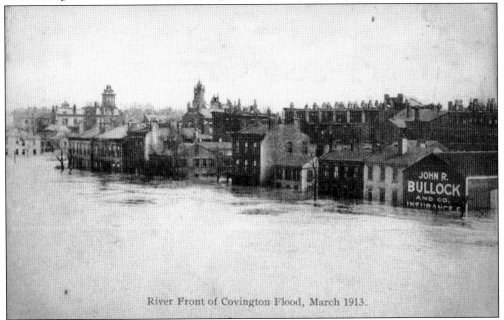

River Front of Covington Flood, March 1913.

At the Covington riverfront, the waters rose to 69.9 feet on April 1, 1913. Schools were used as refugee centers. It was estimated that if the river reached 70 feet that 750 houses would be flooded and 3,000 people displaced. Actually 12,000 people were without homes in Newport alone. Covington was well organized for the flood, and citizens were urged to have a supply of coal set aside.

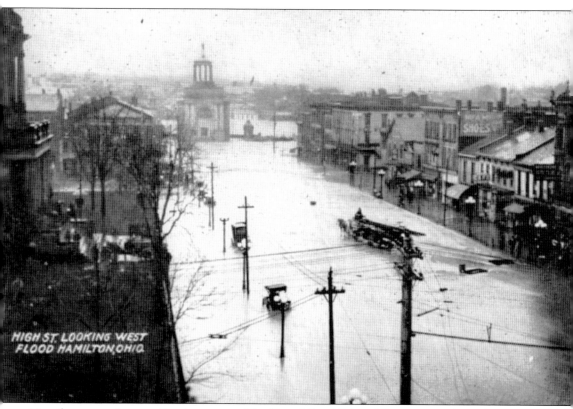

HIGH ST. LOOKING WEST
FLOOD HAMILTON, OHIO.

Hamilton was submerged by the waters of the Great Miami River. The river rose from the usual depth of 4.8 feet to 19.7 feet in one day, during the second 24 hours it reached 34.6 feet. This was the worst disaster in Hamilton's history. The High Street business district, here looking west, was destroyed by 7 to 12 feet of rushing water. Word reached Cincinnati's mayor Henry T. Hunt by the actions of Wade L. Street, who left Hamilton by back roads to ask for help from Cincinnati. As soon as the mayor heard of the conditions, he organized doctors, nurses, and supplies to leave immediately. Street described seeing people on their house and barn roofs surrounded by water, hearing the sounds of trapped and dying farm animals, with the night scene being illuminated by the burning Champion Coated Paper mill. It was estimated that of the 8,000 workmen in the city, 75 percent owned their own homes and most of them had been destroyed. (Author's collection.)

The original powder magazine of Old Fort Hamilton was standing until the 1913 flood. All factories, schools, and stores closed, and bridge access was blocked as the waters rose a foot an hour. Areas nearest to the river flooded to 24 feet. (Author's collection.)

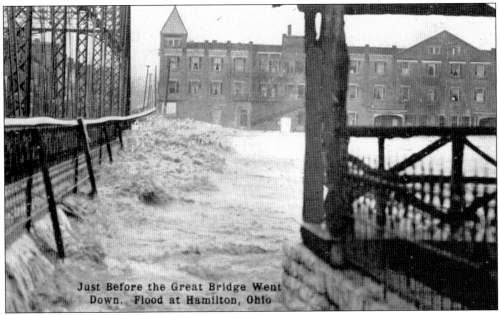

Just Before the Great Bridge Went Down. Flood at Hamilton, Ohio

This photograph was taken from the powder magazine (right) of the bridge just before it buckled. (Author's collection.)

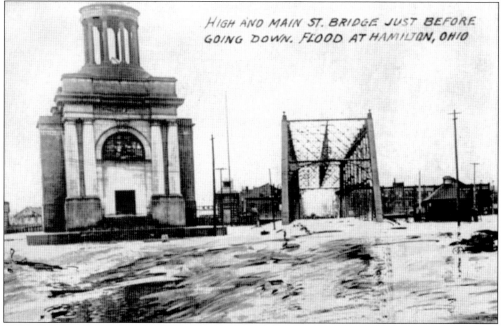

The steel truss bridge and powder magazine (right) are seen here before they both collapsed. The bridge was replaced in 1914. (Author's collection.)

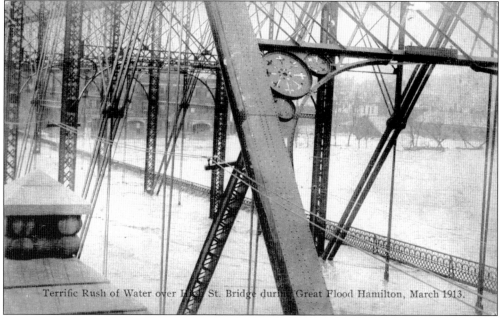

The deck of the High Street bridge was completely covered by rushing waters on March 25, 1913. For Hamilton and Dayton this was truly the "Greatest Flood in Worlds History."

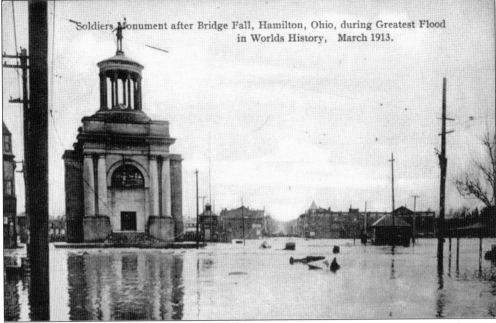

Soldiers Monument after Bridge Fall, Hamilton, Ohio, during Greatest Flood in Worlds History, March 1913.

This is the Soldiers and Sailors Monument after the bridge fell. Built in 1906, it was not harmed by the flood.

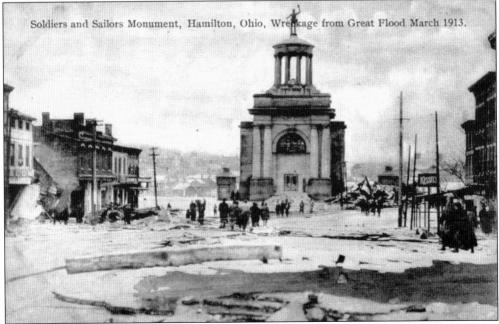

Soldiers and Sailors Monument, Hamilton, Ohio, Wreckage from Great Flood March 1913.

This shows the extent of the wreckage of the High Street business district after the flood. A building on the left has crumbled. One great tragedy was the collapse of the Lakeview Hotel, the foundation was washed away by the current, killing 50 people who had sought refuge there. The St. Charles and the Atlas Hotels remained standing.

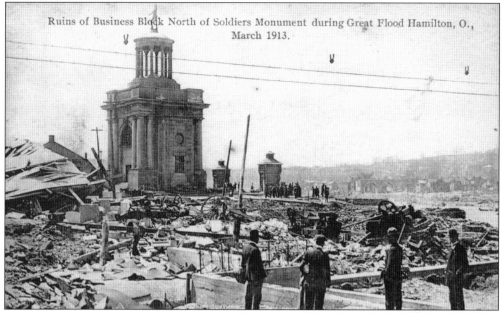

Ruins of Business Block North of Soldiers Monument during Great Flood Hamilton, O., March 1913.

Hamilton was without a water system; electric and natural gas plants were destroyed. Fuel and food surviving the flood was almost nonexistent. A cold front only added to the desperation of the survivors. Ohio's governor James M. Cox was requested by Hamilton's mayor Thad Straub (via telephone to Cincinnati's mayor Henry T. Hunt who called the governor because Hamilton's telephone lines were not working) to send someone to take over the city, which had fallen into chaos.

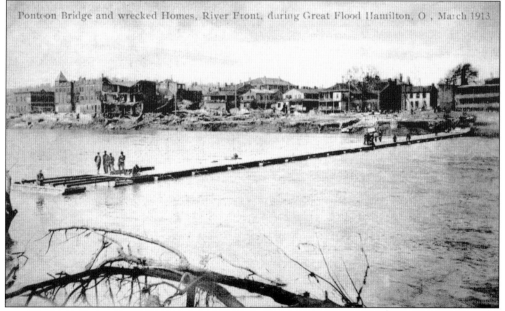

Pontoon Bridge and wrecked Homes, River Front, during Great Flood Hamilton, O , March 1913

Because of the High Street bridge failure, a pontoon bridge was floated between the east and west sides of Hamilton. The War Department was asked to send troops from Fort Thomas, Kentucky, to Hamilton to take charge of the city. One of the soldiers dispatched from there was Lt. Simon B. Buckner, who rose to the rank of lieutenant general in World War II.

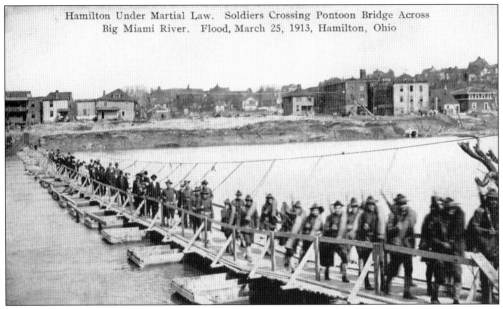

Hamilton Under Martial Law. Soldiers Crossing Pontoon Bridge Across Big Miami River. Flood, March 25, 1913, Hamilton, Ohio

Martial law was declared in Hamilton after the city's resources were overwhelmed in the aftermath of the flood. Col. A. K. Zimmerman of the Ohio National Guard assumed control of the city. A curfew was in effect from 7:00 p.m. to 6:00 a.m. Saloons were closed until April 18. Looters were caught, and rubberneckers were chased. Citizens arrested were tried by court martial, and those convicted served time in Cincinnati's workhouse. For some crimes, Zimmerman had the culprits "drummed out" of the city, not to return. (Author's collection.)

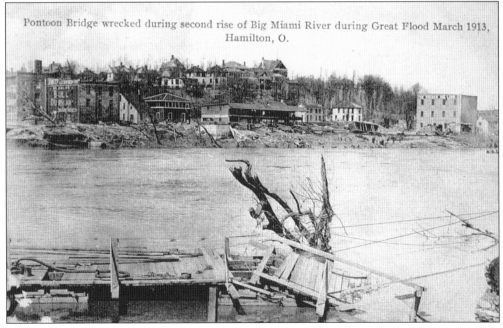

Pontoon Bridge wrecked during second rise of Big Miami River during Great Flood March 1913, Hamilton, O.

Debris in the Great Miami River wrecked the pontoon bridge. Supplies had been hand carried by soldiers across the temporary bridge. Over 300 houses had been swept down the river, some with people crying for help as they floated by, but the current was too swift to attempt a rescue.

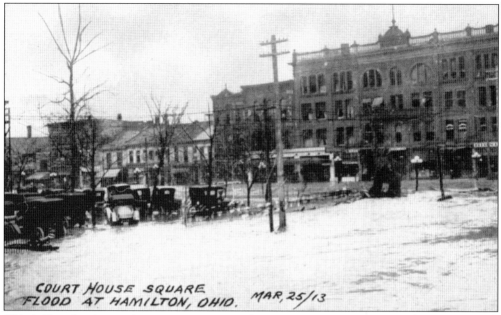

This is Hamilton's courthouse square on March 25, 1913. Coffins were stacked along the east side of the building. Edward Busse of Busse and Borgman Funeral Home recognized the need for undertakers. He formed a group of undertakers, including John J. Gilligan, Joseph Vitt, and Frederick Wrassman, who brought their own equipment, funeral hearses, and horses to help Hamilton. (Author's collection.)

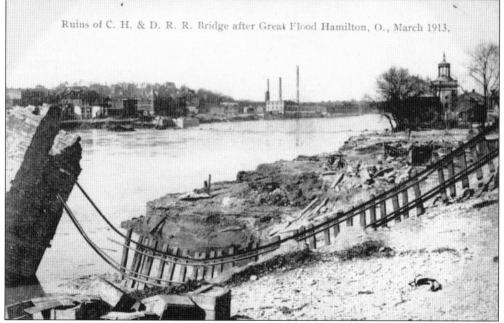

The bridge used by the Cincinnati, Hamilton and Dayton Railroad was twisted by the river. Three bridges were destroyed on the same day; a fourth fell the next day. With telegraph and telephone service nonexistent, Hamilton in its need was isolated from other cities. Tons of debris swept into the bridge piers, and swift-moving water pulled bridge ironwork apart.

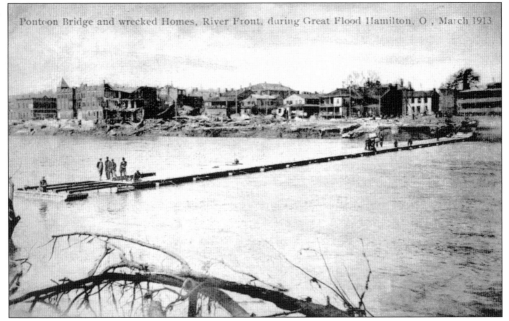

Ruined merchandise lined High Street. The banks extended credit to the merchants, allowing them to continue business. Col. A. K. Zimmerman commented for the newspapers that Hamilton disproportionately suffered the flooding, other cities received more attention, and that Hamilton's distress was not well known. He estimated that 17 miles of asphalt were ruined along with 20 miles of sewers.

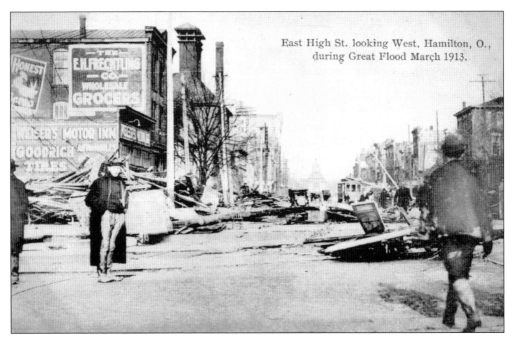

This is East High Street looking west. The corner building on the left has collapsed. Two days after the flood started, the waters had receded.

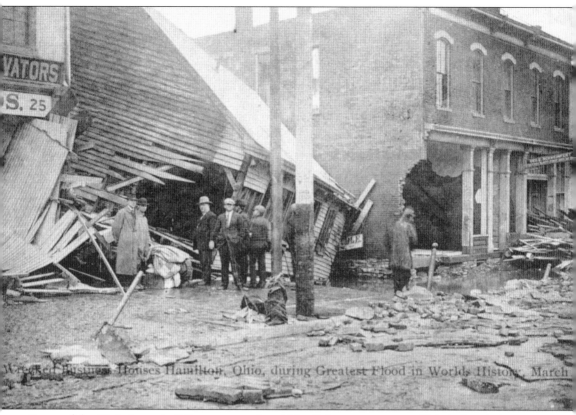

Wrecked Business Houses Hamilton, Ohio, during Greatest Flood in Worlds History. March

Some of the High Street buildings were only rubble. Others were swept off their foundations. Damage reports were taken for every house by men of the militia. Residents were required to cleanup their property once the water had gone, if not, they faced going to jail. As part of this concentrated effort, thousands of animal carcasses were collected and burned in a city park. Some streets had debris 25 feet high. An effort was made to light the city at night, both to aid in rescue and to lift spirits. As soon as possible, factories were reopened and employees were paid a uniform wage of 20¢ an hour to cleanup the factories and the community. Teachers received training as nurses. Financial aid came from across the country, from individual donations, such as the citizens of Mount Healthy ($394), to organizations like the Shriners of San Francisco, who sent $1,000. Conservatively, Hamilton's total loss was $15 million in 1913.

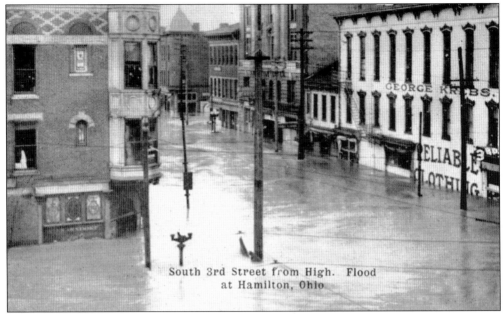

South 3rd Street from High. Flood
at Hamilton, Ohio

The white building on the left belongs to clothier George Krebs in this view of the south end of Third Street.

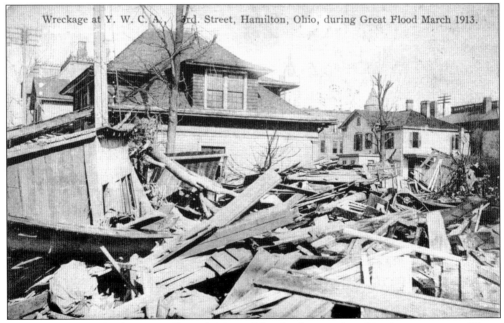

Wreckage at Y. W. C. A., 3rd. Street, Hamilton, Ohio, during Great Flood March 1913.

The YWCA on Third Street collapsed. Lists of the dead were placed in the newspaper. There were almost no buildings left standing on the west side.

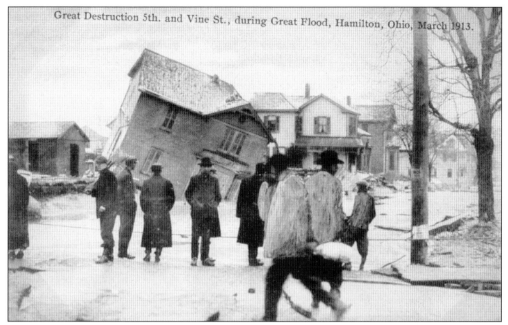

Great Destruction 5th. and Vine St., during Great Flood, Hamilton, Ohio, March 1913.

A Hamilton house moved off its foundation on Fifth and Vine Streets and sits tilted on the street. Over 2,500 buildings were destroyed, 300 people died, and 10,000 were forced from their homes.

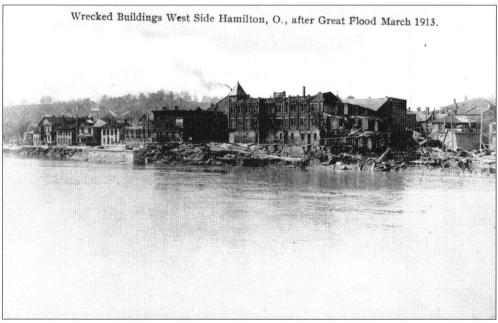

Wrecked Buildings West Side Hamilton, O., after Great Flood March 1913.

As seen from the east side of Hamilton, the destruction of the buildings on the west side of the Great Miami River is evident. Some residents never recovered from their flood losses.

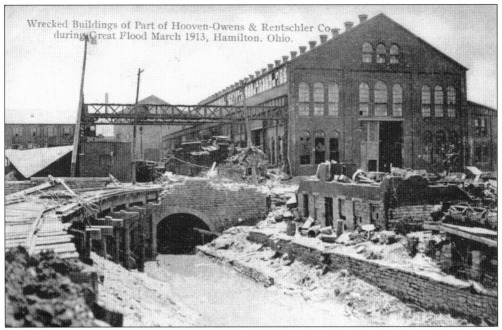

This is what remains of the Hooven–Owens and Rentschler Company of Hamilton. A major Hamilton employer, the company built primarily engines—the Corliss steam engine and gas/steam engines. It supplied Henry Ford's Highland Park plant in Michigan with its engines to move the assembly lines.

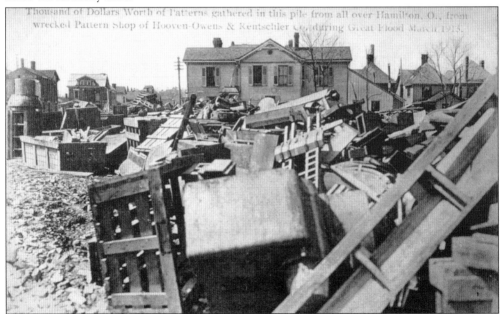

Thousands of dollars worth of patterns were gathered in the pile from the wrecked shop of the Hooven–Owens and Rentschler Company. Other Hamilton manufacturing plants suffered, including the Champion Coated Paper mill, which succumbed to a fire causing $1.25 million in loss. Columbia Carriage Company, Black-Clawson Company, Niles Tool works, American Can, Sohn and Rentschler foundry, and Beckett Paper Company all suffered devastating losses.

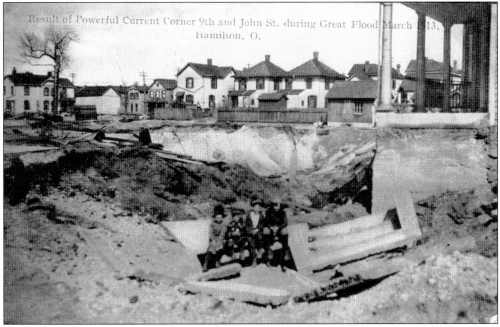

The current was so strong at the corner of Ninth and St. John Streets, Hamilton, that it collapsed the road bed and washed away soil down to the level of this building's footers. The children are sitting next to the house's concrete steps.

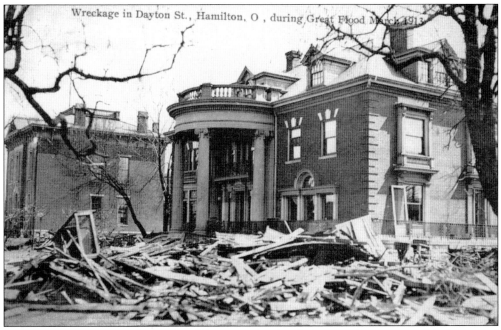

Dayton Street was one of many hard-hit areas. By April 4, paper signs appeared in home and business windows with the following lines by James Whitcomb Riley: "It is easy enough to be happy / When life flows along like a song- / But the man worth while / is the man who can smile / When Everything goes dead wrong."

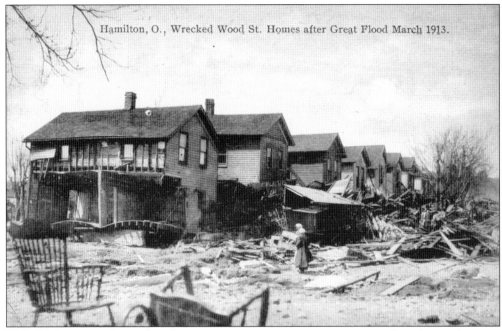

Hamilton, O., Wrecked Wood St. Homes after Great Flood March 1913.

Homes on Wood Street were likewise affected. Troop C, a Cincinnati cavalry of men of society, rode horses to Hamilton to help patrol its damaged neighborhoods from looters. The 40 men also distributed rations and taught about preventing disease through cleanliness.

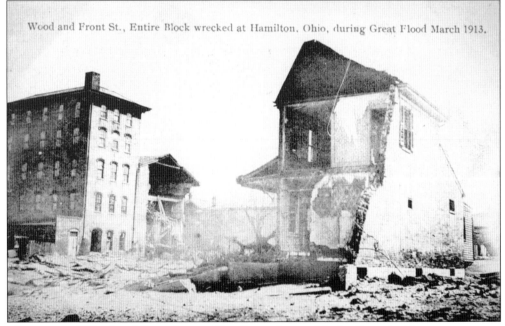

Wood and Front St., Entire Block wrecked at Hamilton, Ohio, during Great Flood March 1913.

The corner of Wood and Front Streets, Hamilton, shows a block of wrecked homes.

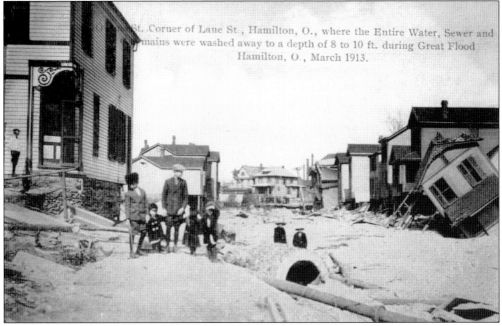

Water and sewer mains were washed away to a depth of 8 to 10 feet here on the corner of Overman and Lane Streets.

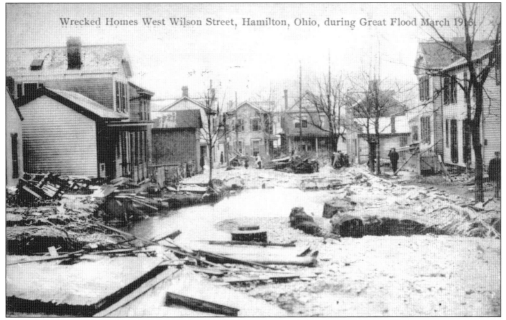

The homes on the west end of Wilson Street show typical damage caused by flooding. After the flood, the Miami Conservatory District was formed, largely through the work of Gordon Sohn Rentschler. Nine counties along the Great Miami River made a plan for flood prevention that included widening the Big Miami River and levee and dam construction. This was accomplished by 1923 without government funding.

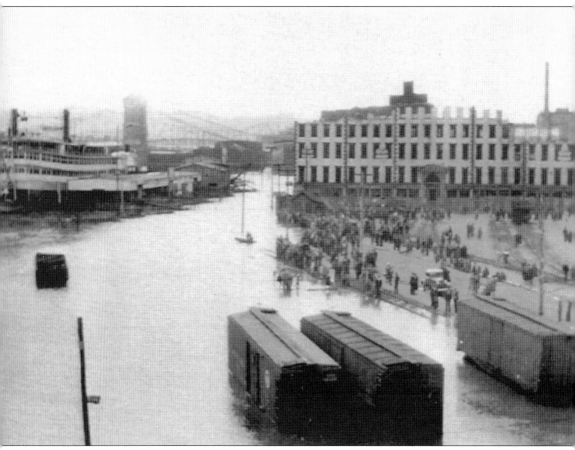

There were two floods in 1933; March 21, with a crest of 63.6 feet, and 54.1 feet on May 15. Heavy rainfall in both instances was the culprit. The waters rose quickly, catching many by surprise. The Mill Creek backed up into Northside and adjacent neighborhoods. The Central Union depot at Third Street and Central Avenue flooded and trains were diverted to the new Union Terminal. The moored *Island Queen* floated back onto the railroad tracks. Over 200 persons were rescued in Reading as the waters of the Mill Creek quickly filled their basements and first floors. Railroad engineers placed a locomotive and a string of loaded coal cars on the Big Four and Baltimore and Ohio steel girder bridge over the Mill Creek hoping that their weight would keep the bridge from washing away. Cracks appeared in the Beechmont levee, and eventually a concrete wall section did give way. The high-water streetcars (unused since 1917) were placed back in service. Everywhere the floods of 1933 destroyed the "depression gardens" that so many families relied on. This postcard is only dated with the year. (Courtesy of Don Prout.)

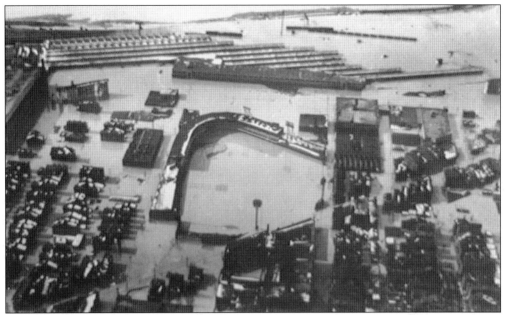

The Mill Creek Valley was submerged during the "great flood of 1937." January's rainfall was four times the average. The rivers and creeks swelled with the heavy rainfall, six inches in two days. The flood was attributed to a mild winter, where the rain should have been snow and thus would thaw and drain gradually. The infield of Crosley Field was covered by 21 feet of water. (Courtesy of Don Prout.)

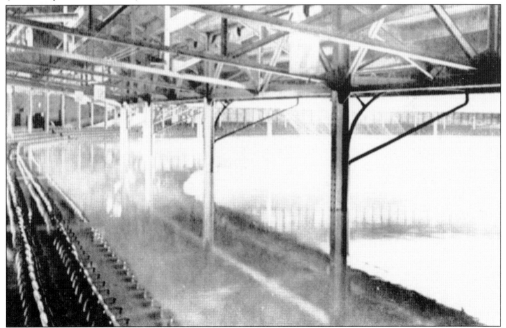

The lower grandstand of Crosley Field had only a few rows of seats left uncovered. Two of the Cincinnati Reds, Gene Schott and Lee Grissom, made baseball history by rowing a boat from Western Avenue over the outfield walls. The ball park was cleaned and ready for opening day. (Courtesy of Don Prout.)

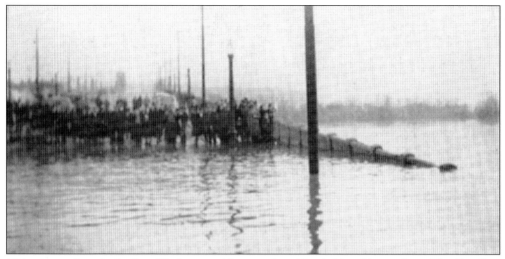

Citizens stood on the Ludlow Viaduct, unable to get into Northside without a boat. The flooding lasted 19 days. Over 100,000 were made homeless by the flood, and nearly 20 percent of the city was underwater. The death toll for the entire area flooded over several states was 385 with 10 of those locally. Total damage for the flood-affected area in all states was $500 million, which in 2005 would be $6.7 billion. (Courtesy of Don Prout.)

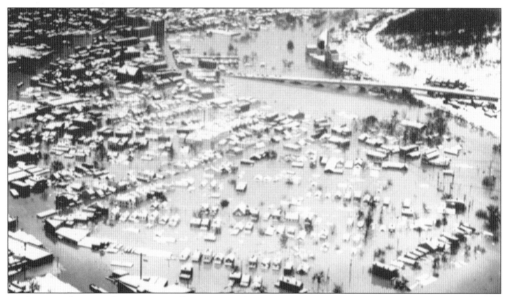

In this aerial view of Cumminsville and Northside, the viaduct is on the upper right and slopes into the waters of Mill Creek. Coal and food trains were stopped by flooded tracks. Nothing moved in or out of the new Union Terminal. Hamilton, which Cincinnati helped so much in the 1913 flood, repaid in kind, sending needed water, supplies, and surplus electrical power south. Dayton, too, supplied emergency power and water. (Courtesy of Don Prout.)

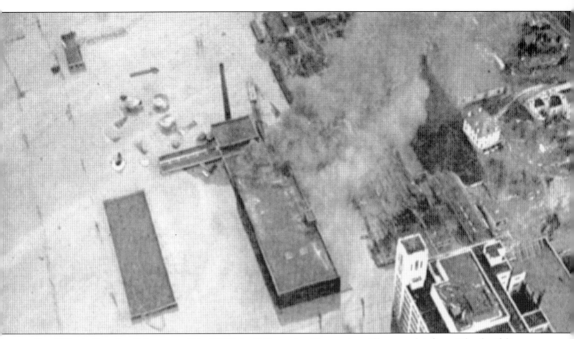

On "Black Sunday," January 24, 1937, buildings in Cumminsville caught fire. The building at lower right is the Crosley Radio Corporation refrigerator plant. Right of center there are gas tanks that have broken free of their moorings. Exploding gas tanks and leaked gas and oil floating on the water caught fire from a broken trolley wire, creating large fires in the Mill Creek Valley. One million gallons of gasoline ignited. Firemen were joined by police, prisoners from the workhouse, and citizens to fight the fire along a three-and-a-half-mile front. Fire company pump vehicles put their suction hoses into the floodwaters to fight the great fire, which burned for 36 hours. Property loss from the fire was estimated at $5 million. On this day, the water pumping station was flooded so the city was without potable water and there was no electricity because Cincinnati Gas and Electric (CG&E) generators were likewise underwater. Many two-story houses were covered to the roofline and were total losses. For 18 days the city struggled, finally on February 5 the river went back in its banks. (Courtesy of Don Prout.)

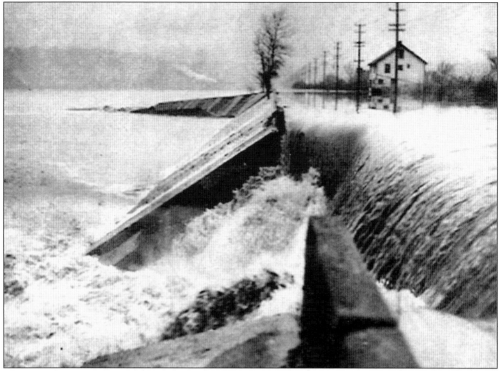

Floodwaters surged over the breached Beechmont levee dike, creating rapids as it poured over a 20-foot embankment. (Courtesy of Don Prout, Zanol Products Company flyer.)

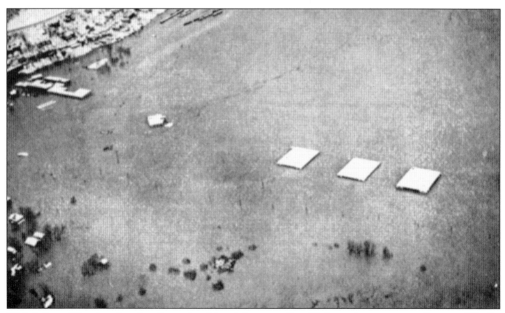

This is how "Sunken Lunken" received its nickname. For 17 days, there was no plane traffic. In 1941, a new airport was needed because of the damage sustained in this flood. Needing federal monies to build a new regional airport, only northern Kentucky had land that met federal guidelines for elevation and flat terrain. (Courtesy of Don Prout, Zanol Products Company flyer.)

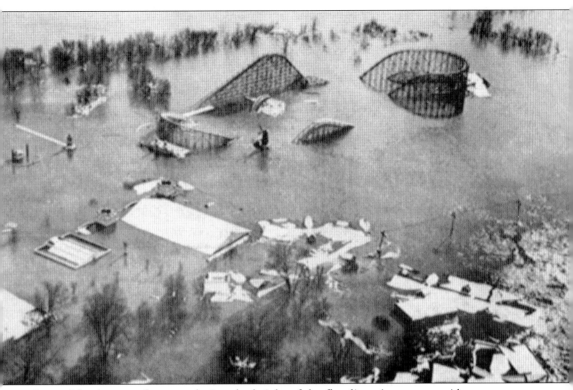

Coney Island was underwater during the height of the flooding. Amusement rides were seen floating down the river. There was more damage to Coney Island from this flood than any other. During the period of January 6–25, it rained heavily, as much as five inches in five days. The stables floated away from River Downs and smashed Coney Island's buildings. Mud penetrated into all the ride machinery. Edward Schott, president, announced he would spend $300,000 for the repair and renovation of the park. When Coney Island reopened on May 22, there were new rides, a new cafeteria, and a renovated Moonlight Gardens. A new clubhouse was completed a little later. New rides that were still there 30 years later included the Wildcat, Cuddle Up, Funhouse, Whip, Ferris wheel, and the merry-go-round. After the flood, the recently created U.S. Corps of Engineers was given the task of implementing flood control along the Ohio River. (Courtesy of Don Prout.)

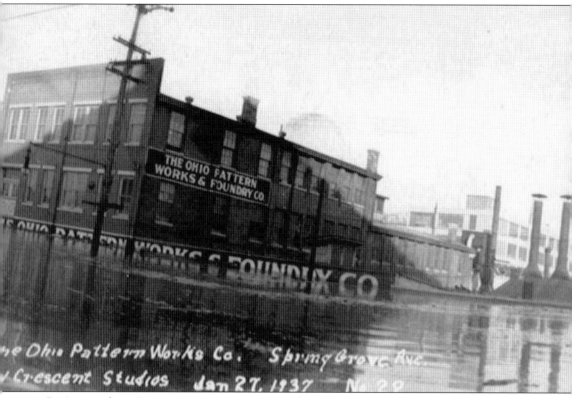

The Ohio Pattern Works Co. Spring Grove Ave.
Crescent Studios Jan 27, 1937 No 22

Businesses along Spring Grove Avenue sustained heavy damages. After the water receded, six inches of smelly, sticky mud remained. Despite all of the billions spent since then, the severity of possible flooding has only been reduced by 10 feet. Northern Kentucky hunkers down behind levees and floodgates after one third of Campbell and Kenton Counties had been submerged. The Mill Creek flows on a concrete bed. Lakes, dams, and reservoirs have been built to hold back floodwaters. Yet approximately only one-third of the waters flowing into the Ohio River are under some control. It was the greatest flood of that century, yet with all of the 60 years of preparations, it could happen again. (Courtesy of Don Prout.)

Residents (right) look out of a residence above a store in lower Price Hill. Multiple families crowded together as the flooding worsened. People were asked to burn only one light and keep one radio on so they could hear emergency bulletins. Clean water was obtained through a network of neighborhood distribution stations of tank trucks or natural springs. Long lines formed in the winter's cold as people stood waiting to fill up pails and copper wash boilers with the potable water. (Courtesy of Don Prout.)

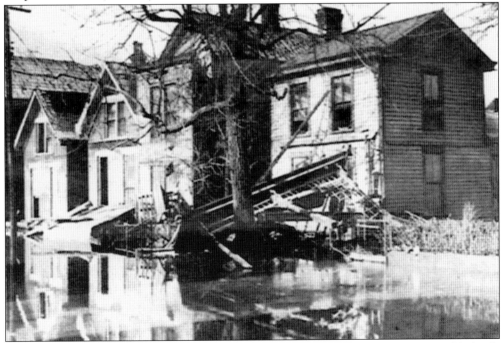

After the waters receded, the extent of the damage and debris left by the 1937 flood could plainly be seen. One-sixth of Hamilton County had been underwater. More than 100,000 local people left their homes. (Courtesy of Don Prout.)

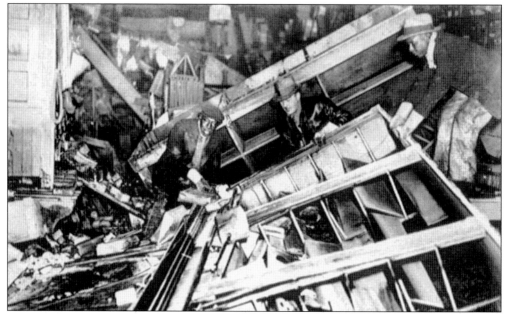

This is the wreckage of the George Schorr store, located at Pearl and Vine Streets. The Ohio River crested at 79.9 feet on January 25, 1937. Total damages for this region were $20 million. The Suspension Bridge was the only bridge crossing the Ohio that was kept open. (Courtesy of Don Prout.)

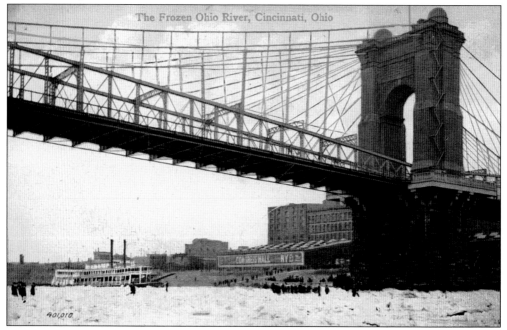

Of yearly concern was the possibility that the Ohio River would freeze for weeks at a time, stopping all river commerce. The river could be frozen completely to the bottom or have a deep icy crust. When the ice broke and moved, it would be in small channels. Ice shards would be thrown up for 15 to 20 feet on either side of the channel, which could be miles long. The ice would gouge, crush, and splinter anything in its path. This is the January 1905 ice gorge.

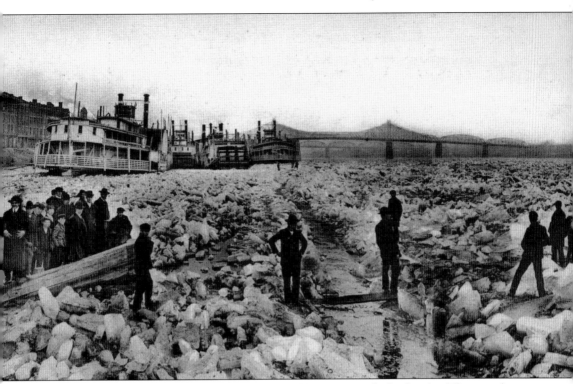

This early-1905 postcard has adventurous people walking among the broken ice. The steamboats here are locked in ice along the shore. Near North Bend, the ice was piled nearly 30 feet high and the water was frozen completely to the bottom. Dynamite was used to break apart the ice with limited success. The Ohio River from Pittsburgh to the Mississippi River was strewn with steamer wreckage, smashed piers, all manner of watercraft, and ships locked in the ice to be reduced to rubble once ice gorges formed. There was a coal shortage created by the hundreds of coal barges sunk and the stoppage of all rail traffic. During the same time, ice floes filled New York's harbor, Chicago's riverfront was iced in, and heavy sleet brought down telegraph and telephone wires and stopped trains throughout the south. A million dollars worth of watercraft was menaced at Cincinnati, and the river was impassable for 56 days.

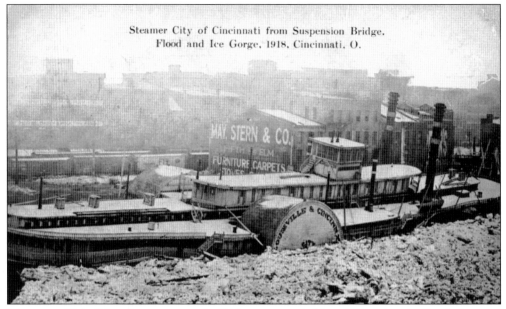

Steamer City of Cincinnati from Suspension Bridge.
Flood and Ice Gorge, 1918, Cincinnati, O.

The worst Ohio River ice gorge was in 1918, accompanied by a blizzard and a flood. Ice, two feet thick, precluded steamboat traffic for eight weeks. With a loud crack the ice started to split at 10:00 a.m. on January 30. Steamer whistles blew, passing along the signal of movement in the ice. The *City of Cincinnati* was caught and damaged by the ice and started to sink. Built in 1899, it was salvaged for its doors, windows, pilot wheel, and anything else reusable. Whatever wood remained was burned on the public landing.

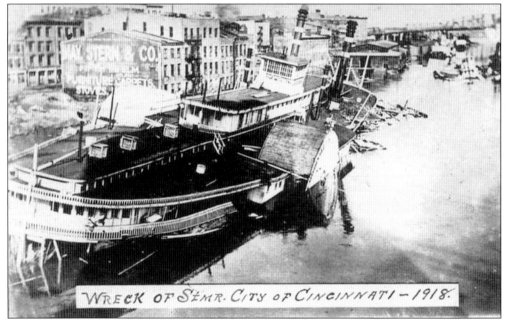

WRECK OF STMR. CITY OF CINCINNATI – 1918.

The *City of Cincinnati* lists on the bank between Main and Walnut Streets. It was hoped that when the river rose, the steamer would float off the bank. It was owned by the Louisville and Cincinnati Packet Company. Its sister ship was the *City of Louisville*, which fared no better that winter. (Courtesy of Don Prout.)

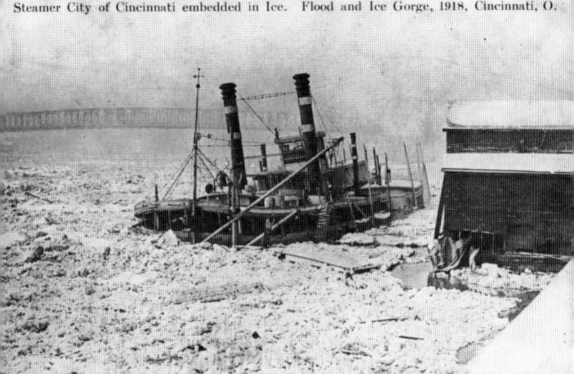

Aboard the *City of Louisville*, at the foot of Ludlow Street, two men on deck will stay on board until the last moment, trying to keep the boat moored. The *Hercules Carrel*, a small harbor vessel, broke the ice around the trapped steamer and tried repeatedly to free it. The largest and fastest passenger packet on the Midwestern rivers, the *City of Louisville* was called "Champion of the Western Waters" by its captain, who was the last to leave the ship. It earned the moniker, which was emblazoned in gold upon its gangway, by traveling from Cincinnati to Louisville in 5 hours and 48 minutes. Its sinking protected other boats trapped in the ice along the shore below it, by deflecting damage from ice, boats, and barges as they swept past. Eight steamers and six packet boats were in the ice here, most insured by Neare, Gibbs and Lent.

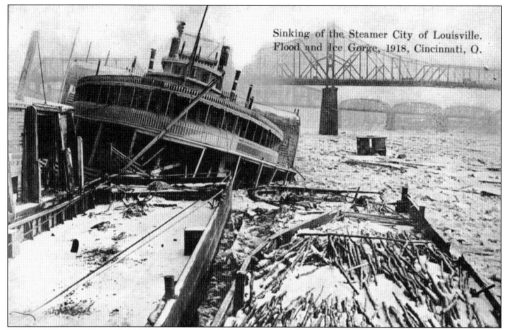

The *City of Louisville* slowly sinks from a gash in its hull, on February 1, 1918. It was torn from its cables and gashed its entire length by a passing barge. It then listed to one side and sank in shallow water just above the Coney Island wharf. In the *Cincinnati Enquirer* the ship's skipper, Captain Mackelfresh, was quoted as saying, "Boys, the old gal is laid out there for your last look . . . she won't be with us long."

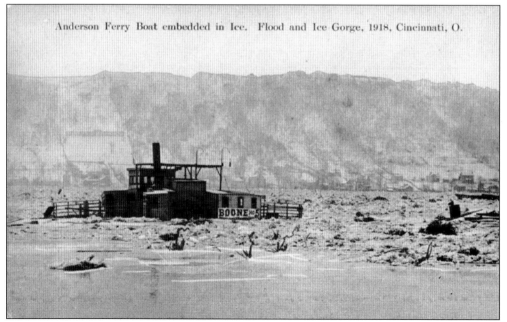

While the Anderson Ferry is still iced in, the river is free flowing only yards away. Ferry boat *Boone No. 5*, owned by Harry Kottmeyer, sank from a 20-foot hole in its side. The fuel flatboat and another ferry boat used at night were on the Kentucky shore and sank.

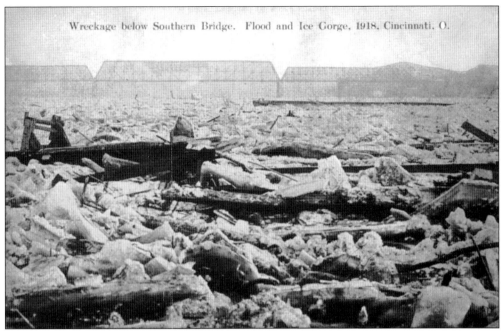

Wreckage of boats added more debris to the ice floes. Unsecured barges damaged boats moored to the shores.

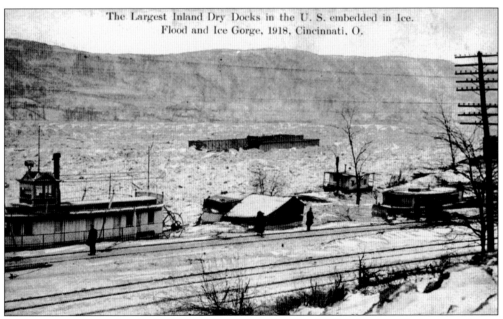

Having a steamer in dry dock did not always save the vessel. The river could rise once the ice was broken up and float a streamer back into the river, there to be trapped if the waters refroze, or damaged by ice and wreckage.

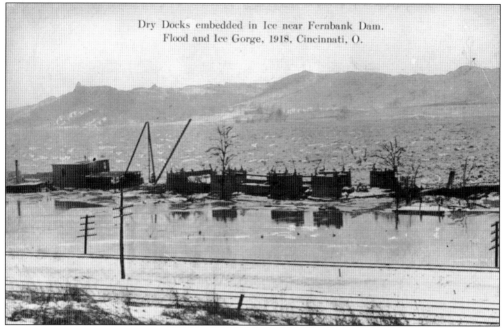

Downriver the dry docks near Fernbank Dam are surrounded by ice.

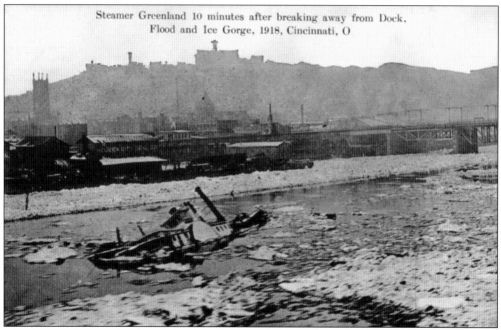

The *Greenland* was in dry dock at the Queen City Marine Ways in the East End. In the background is Mount Adams. The river rose rapidly, floating the steamer and tearing it free. Within 15 minutes, it went down and was a total loss. Gordon Greene, owner of the Greene Line steamers, saw three of his wharf boats sweep past him in one morning. The *Greenland* was the finest of his steamer line.

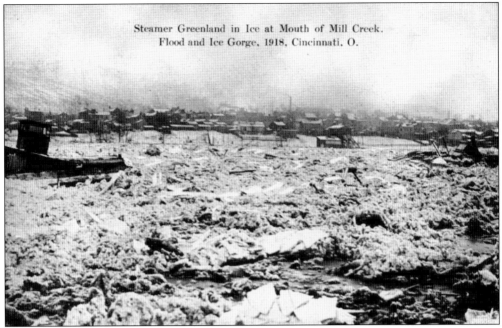

Steamer Greenland in Ice at Mouth of Mill Creek.
Flood and Ice Gorge, 1918, Cincinnati, O.

Against the Kentucky shoreline, the *Greenland* is sunk. It was later looted of two chairs, 200 feet of rope, two axes, two oars, and the whistle. Two men were apprehended.

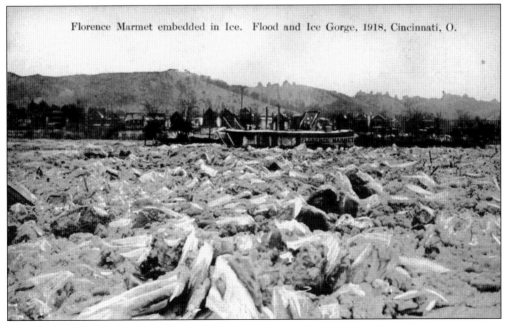

Florence Marmet embedded in Ice. Flood and Ice Gorge, 1918, Cincinnati, O.

The *Florence Marmet* is being ground apart by ice, however, the ship stayed afloat.

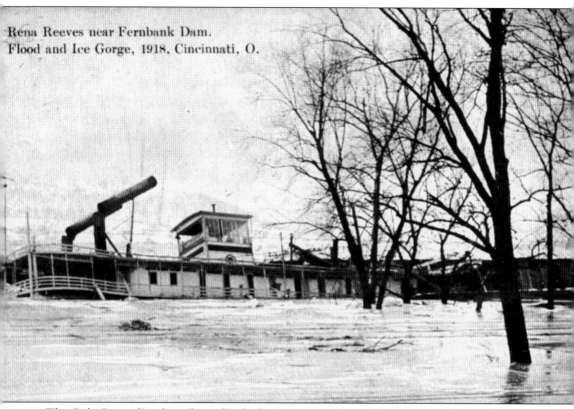

Rena Reeves near Fernbank Dam.
Flood and Ice Gorge, 1918, Cincinnati, O.

The *Rebe Reeves* lists heavily at the dock. It was a towboat belonging to the Hatfield Coal Company and sank in the harbor owned by the Island Creek Coal Company at Sekitan, near North Bend. Over 100 coal barges were lost, and coal yards along the river were flooded. There was a great shortage of coal that almost shut down the power plant that supplied heat and light to Cincinnati. Factories and schools were closed for lack of fuel. It was suggested that the hours of saloon operation be shortened, or that they close altogether, and that the breweries should shut down. The coal saved could be then diverted to the public schools. A man was shot and killed by a Baltimore and Ohio Railroad detective for stealing coal. The boat's name is incorrectly spelled on the postcard.

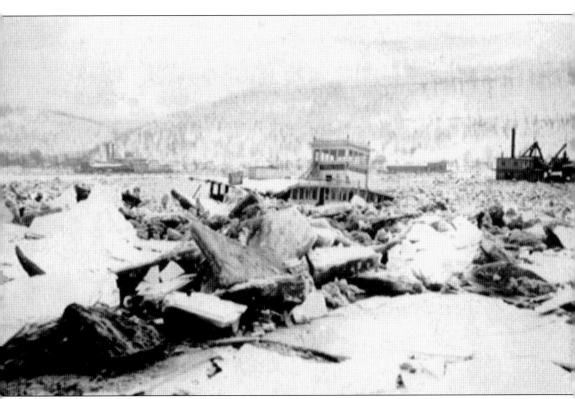

The *Island Queen* is being pushed down the river by ice. This boat and the *Island Princess* were both at dock on the Kentucky River at Carrollton, Kentucky. When the ice broke, the *Island Queen* rammed the *Island Princess*, crushing its hull. Both boats were swept downriver, and the *Island Princess* sank. The *Island Queen* did not sink but was badly damaged. The *Island Princess* was valued at $75,000. The *Morning Star* took the place of the *Island Princess* when Coney Island opened for the season. (Courtesy of Don Prout.)

Shanty Town at Mill Creek. Flood and Ice Gorge, 1918, Cincinnati, O.

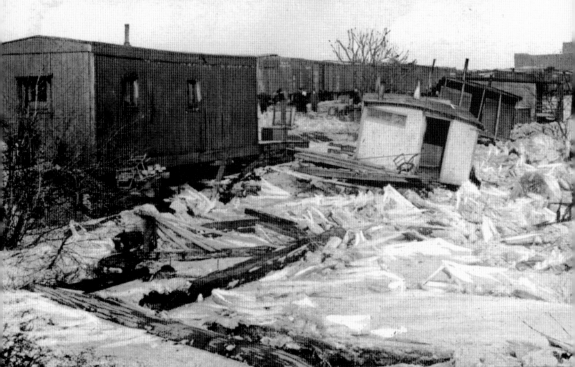

Shantytown was located at the mouth of the Mill Creek and the Ohio River. In started in 1884 when a dozen or so houseboats were stranded there after the floodwaters receded. During subsequent floods, more boats were added until a small community was formed. The shanty boats were not scattered about but were arranged in street formation. Typically they were three small rooms: parlor, bedroom, and kitchen. By the end of 1907, a different type of resident joined, building shacks on higher ground. The occupants had a trade or a job. The boats were not permanent, and for part of the year, some occupants would tie up to a towboat going up the river, stay wherever they dropped anchor, and float back down the Ohio to shantytown. The community had a gospel mission and a grocery store. The winter of 1918 was the last for Shantytown. The boats and shacks were cleared off by the coal companies that owned the land.

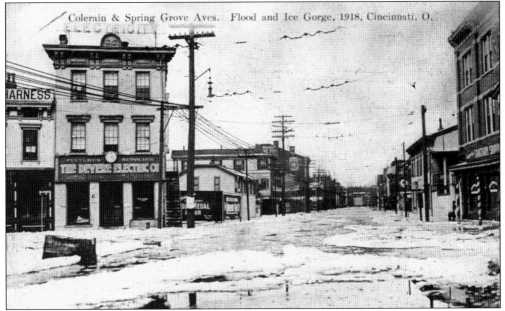

The Mill Creek, along with any feeder creeks and streams, would back up, the ice acting as a dam preventing emptying into a larger body of water. The resulting floods, while not reaching second-story height, still invaded first floors of residences and businesses and forced some evacuations.

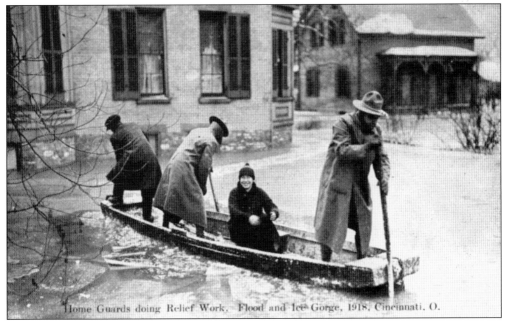

The Home Guards were a forerunner of the National Guard. They helped to move people to higher ground or shelters, brought fuel and food to those stranded, and prevented fires.

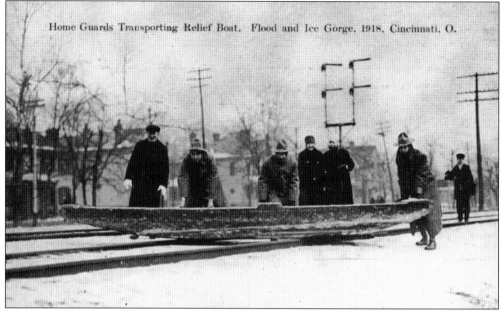

Balanced across the railroad tracks, the Home Guards move their skiff. The shallow draft and narrow design fit down Cincinnati's narrow streets and were very maneuverable.

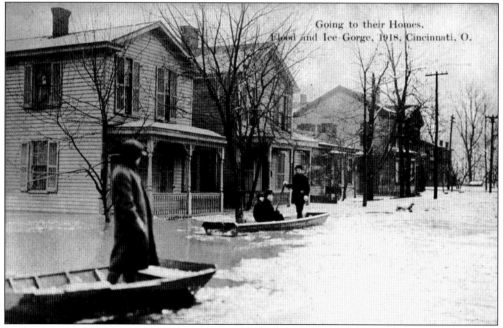

Once the ice gorge was broken on the Ohio River, the Mill Creek would retreat, the streets would once again be useable and the cleanup would begin. It was not until the floods were somewhat controlled by dams and conservation measures by the U.S. Army Corps of Engineers that this annual pattern in many low-lying neighborhoods would cease.

Two

AIR

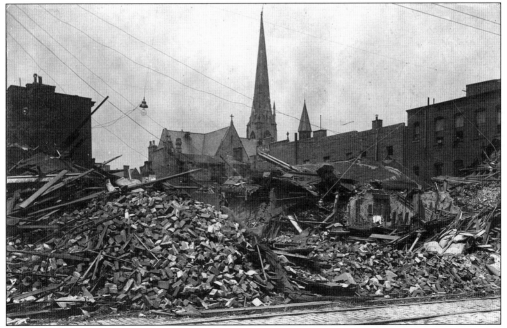

On the evening of Wednesday, July 7, 1915, a deadly storm swept into Cincinnati and northern Kentucky. When it was over, 38 people were dead, the most ever recorded for a non-tornado event. No one saw a funnel-shaped cloud, and the winds only reached 60 miles per hour. Today this would be called a microburst. Property damage went over $1 million.

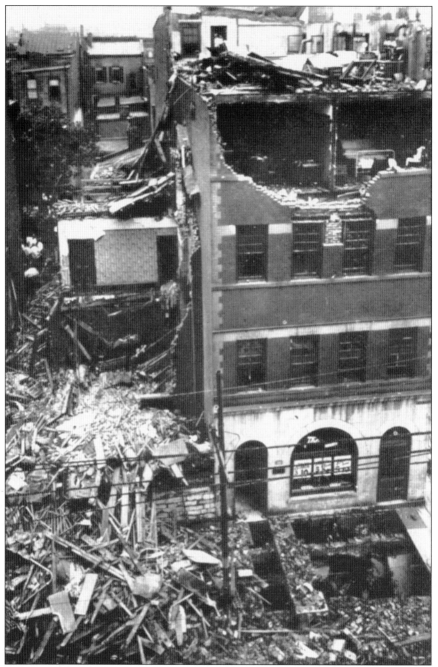

At Eighth and Cutter Streets this building collapsed, killing six. Most of the tornado deaths were from collapsed dwellings. At 643 West Eighth Street, five people of the Tennenbaum family died. The storm struck at night when people were getting ready for bed. By midnight, the streets were packed with people looking for survivors or who were displaced by the storm themselves. The streetlights were not operating, making the search more difficult by torch and flashlight. Throughout the night and the next day, survivors were dug free of the wreckage, including buried horses. Nearby another six buildings fell. The gale was accompanied by heavy rainfall.

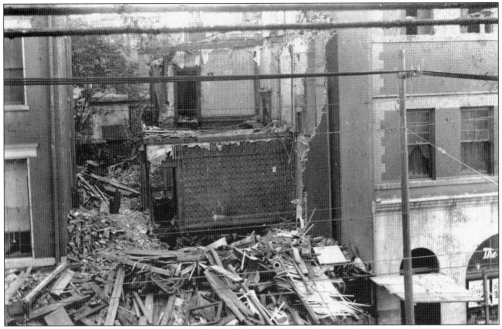

Meyer Tennenbaum lost his wife, mother, sisters, and his daughter. The top story of the next-door building collapsed onto the Tennenbaum building, crushing his family. The building next door held the bodies of six more of his relatives, the Cohen family.

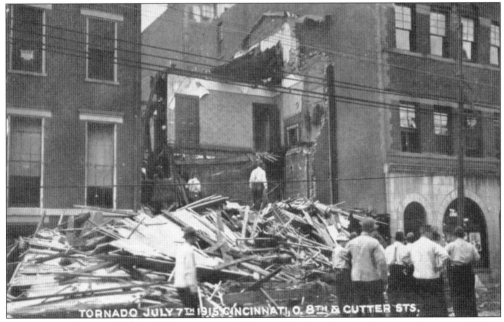

TORNADO JULY 7TH 1915 CINCINNATI, O. 8TH & CUTTER STS.

Isaac Tennenbaum, father of Meyer, was talking to his daughter-in-law on the second floor when the building fell. He was carried, still sitting in his chair, to the first floor. Falling rafters formed an arch, protecting him from falling debris. His daughter-in-law was not as fortunate and was buried.

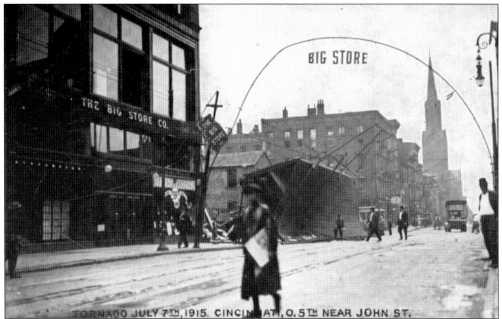

Some windows of the Big Store were blown out, while the building next to it sustained heavier damage. In the business district, losses were broken glass, blown over signs, and merchandise damaged from the heavy rains. Through the action of wheels and walking, glass was ground to dust and blew into the faces of the rescuers.

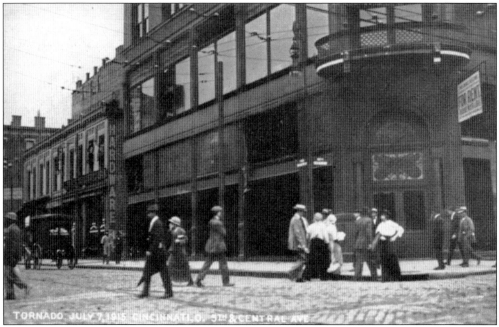

All the storefront windows were broken at Fifth Street and Central Avenue. City hall had its clock face blown out of its tower and into the street. Hundreds of lights in the building were shattered. St. Peter in Chains Cathedral lost part of its tin roof, which was blown across the street. The Isaac Wise temple lost the northeast corner of the building.

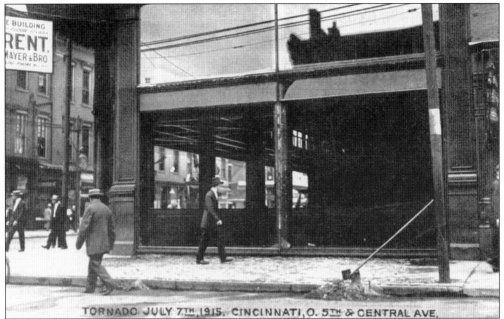

TORNADO JULY 7TH 1915. CINCINNATI, O. 5TH & CENTRAL AVE.

The damaged store was empty and for rent. One man in the Odd Fellows temple was killed by the falling ceiling. Watchmen and elevator men reported that tall buildings downtown swayed with the force of the wind.

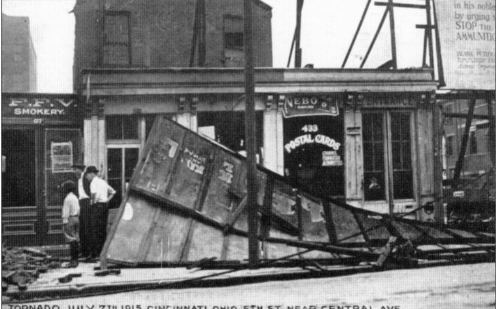

TORNADO JULY 7TH 1915 CINCINNATI, OHIO. 5TH ST. NEAR CENTRAL AVE.

The billboard above this store was toppled. Telephone and telegraph lines were down everywhere. Telephone poles downtown held 92 single wires attached to 10 cross arms along with a cable containing another 10 wires. People who noticed the sky before the storm hit reported that it was a deep green.

TORNADO JULY 7TH, 1915. CINC

The tin roof at Ninth Street near Mound Street was peeled back. Streetcars could not operate because of downed wires. Telephone and telegraph wires were also down. The house next door was also damaged. Several steamboats were overturned on the river, their crews missing and

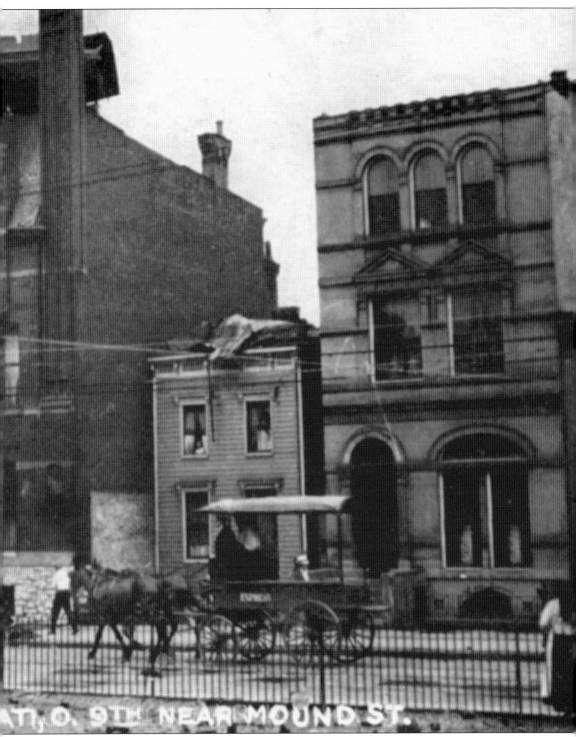

assumed drowned. Buildings throughout the city had to be inspected for damage. Even houses in the then suburbs of Price Hill, Delhi, Mount Adams, and Mount Auburn sustained damage.

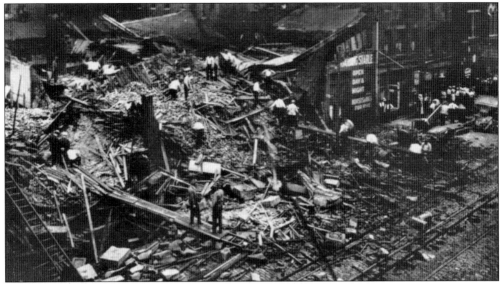

Five buildings collapsed and 18 people died at Sixth and Mound Streets. A saloon at 572 West Sixth Street was destroyed, trapping eight people. Police, firemen, and citizens labored through the night to locate those buried in rubble.

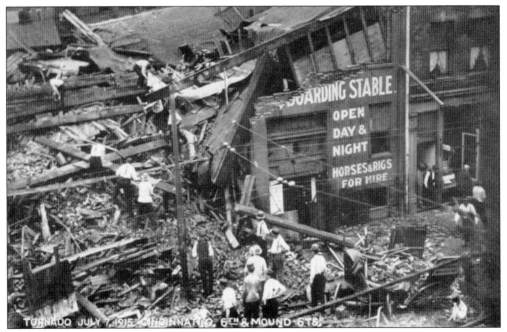

The buildings were totally destroyed at Sixth and Mound Streets. At least 50 people had been trapped. An additional 11 people died in the collapse of two houses on Sixth Street.

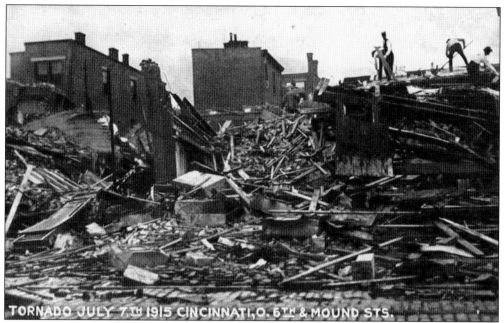

Only rubble remained.

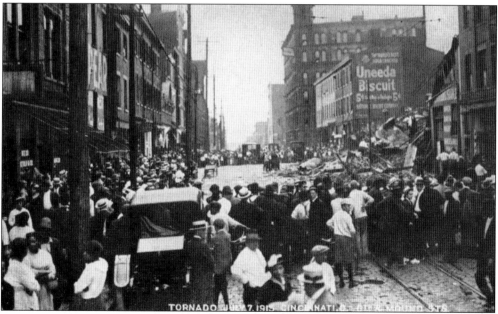

A building collapsed onto the street at Sixth and Mound Streets. At the Banner Vinegar Company and the Mammoth Tobacco Works, the top floors fell. Chimneys and smokestacks throughout the city were blown down. Part of the decorative facade of the German Protestant church at Twelfth and Elm Streets fell.

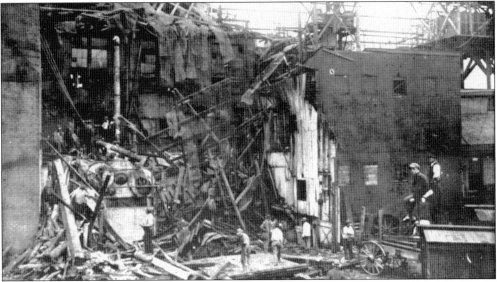

A partial shell was what remained of the Cincinnati Ice Company's plant at Court and Broadway Streets. Ice-making equipment was buried by a falling wall, and the condenser on the roof fell into the wreckage of the building.

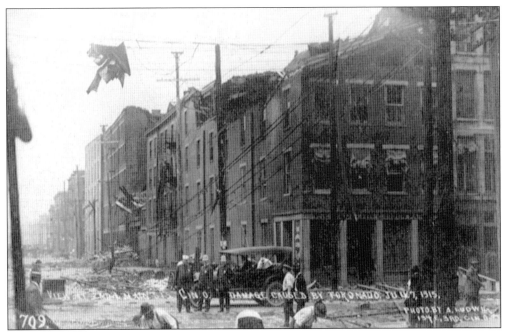

The corner building at Second and Main Streets had a heavily damaged third and fourth floor. They appear to have fallen onto the second floor. (Courtesy of Don Prout.)

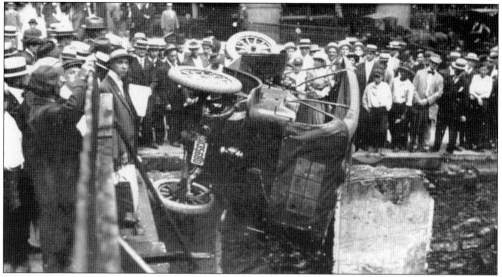

This automobile was blown from in front of the Gibson House. The wind carried it 200 feet down Walnut Street to Fourth Street, where it lodged on the foundation of the old demolished Carlyle building.

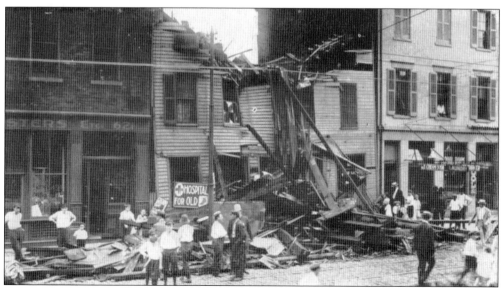

These are the ruins of the dwellings on East Pearl Street. The steeple of St. Philomena Church fell on these frame homes across the street from the church, crushing them. Heavy timbers were blown a block away.

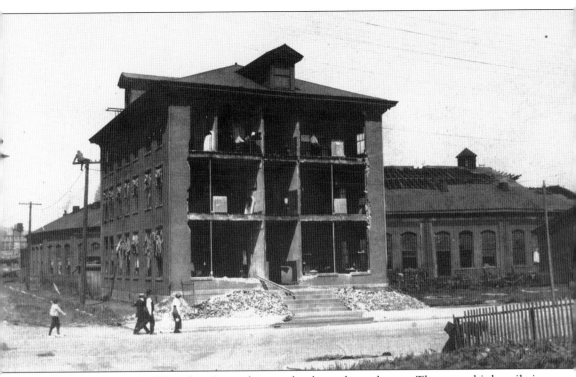

The front of this building, location unknown, has been sheared away. The storm hit heavily in Milford and Terrace Park, where a train loaded with racehorses was blown off the tracks, killing three men and 11 horses, and injuring 10 other horses. The men had been in various train cars and were killed by the kicks of frantic horses. The wooden car next to the engine had been lifted off the tracks, dragged for 75 yards, and toppled down an embankment. Several of the train crew ran through the storm seeking help from residents of Milford and Terrace Park. With axes and lanterns, volunteers did what they could to free men and horses until the veterinarian and doctor arrived. Nineteen men were sent to Good Samaritan hospital. The injured horses were taken to the former winter quarters of the Robinson circus. The horses, along with stablemen and several owners, had originally left Latonia Racetrack. The train was headed for the racetrack in Saratoga, New York.

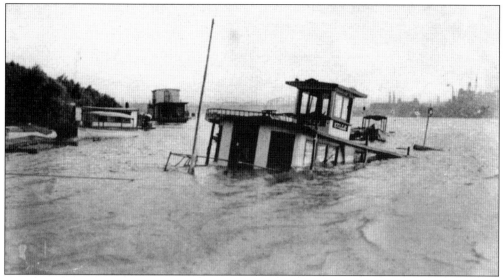

The pleasure boat *Kelle*, owned by F. S. Hesley, was in Bellevue, Kentucky. It sank with the loss of the machinist, who was last seen dropping anchor. Other vessels were overturned by the wind with an unknown loss of life. The *Island Princess*, loaded with passengers, safely made it to shore.

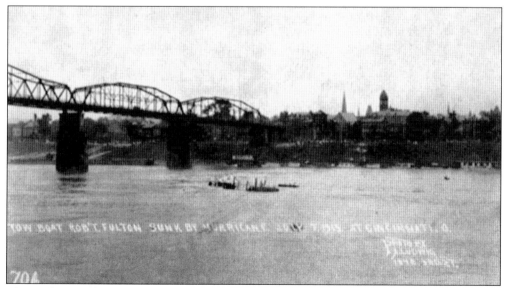

The towboat *Dick Fulton*, owned by the Queen City Coal Company, sank at the foot of Lawrence Street, taking the captain, Bradford Williams, down with it. The boat had been making a return trip from Aurora towing a barge of coal.

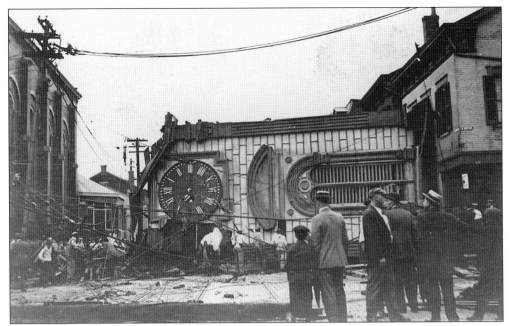

St. Joseph's Church, on Twelfth and Greenup Streets in Covington, lost its clock tower and steeple in the same storm of July 7, 1915. Over 1,000 buildings in northern Kentucky suffered damage. The stables at the Latonia racetrack were flattened. A bridge over the Licking River was knocked off its pier.

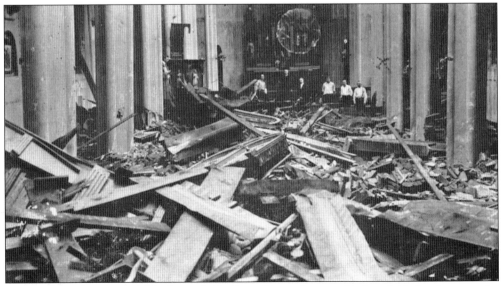

St. Boniface Church on Adela Street in Ludlow, Kentucky, was hit broadside by the tornado. Only the tower and part of the apse were left standing. The interior was filled with broken rafters and glass. The church was built around 1893. The damage was $30,000.

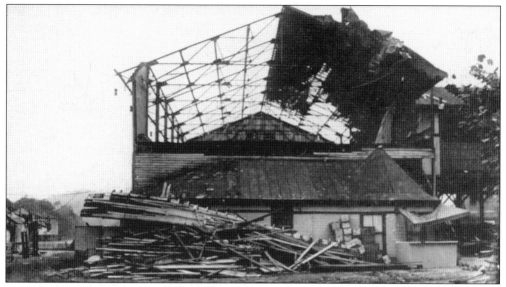

The wreck of the dancing pavilion at Ludlow's Lagoon Amusement Park included a missing roof. Only the dance floors were left intact. Lagoon Park closed in 1919. The rebuilt dance pavilion burned in 1921.

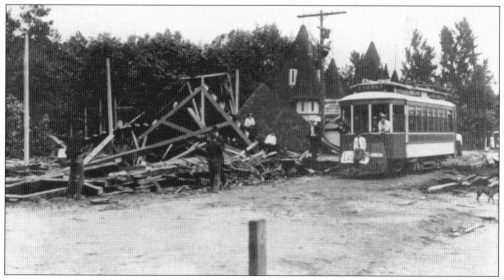

The waiting station at Lagoon Park sustained heavy damage. Rides were ruined, and the clubhouse lost part of its veranda. The cost from this event to Lagoon Park was $50,000. The clubhouse was later converted into an apartment building.

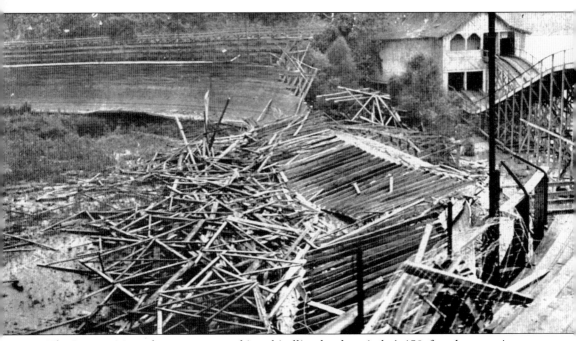

The Lagoon Motordrome was turned into kindling by the wind. A 150-foot-long section was torn away, trees were uprooted, and buildings were crushed. Ludlow's Lagoon Amusement Park, opened in 1895, emphasized entertainment over amusement rides. The 25-foot-deep Lagoon Lake was formed by damming the Pleasant Run Creek and featured swimming and sailing. An amphitheater, seating 2,000, sat at one end of the lake with a bandstand extending over the water. Bands, vaudeville acts, dancing troupes, diving horses, circus acts, jugglers, fireworks, comedians, dances, and railway rides could be seen for a quarter's admission. A large Ferris wheel, like that popularized in the World's Columbian Exposition in Chicago, was constructed. During the hot and humid summer months, the coolness of the lagoon attracted people in droves. For all its popularity there was a succession of owners. The lagoon would overflow and leak, and river floods kept it in need of seasonal repair and cleaning. Several people drowned, and a motorcycle spun out of control at the motordrome, exploding and injuring nearly 200 people. Sixteen died and lawsuits abounded, forcing the motordrome into bankruptcy. Twenty-six years after it opened, the Lagoon Park closed. Contractors in 1923 built houses on the lagoon's site, and the lake was filled in by contractors in 1967.

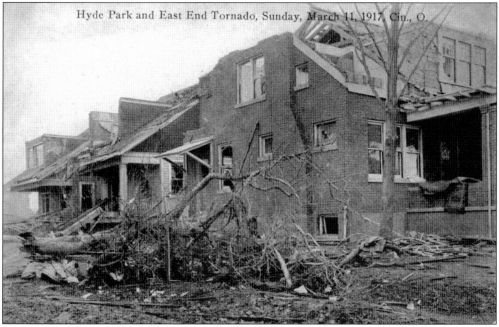

As surprising as it seems, the first tornado on record in Cincinnati hit Hyde Park, O'Bryonville, Mount Lookout, Ault Park, and East End on Sunday, March 11, 1917, between 7:20 and 7:30 p.m.

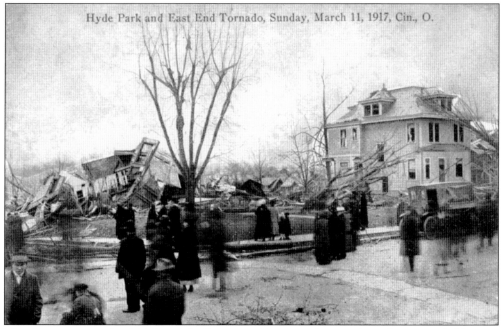

The damage started at Fairfax and Cinnamon Streets and crossed Madison Road, blowing down wires, trees, and signs. It skipped across the grounds of the Cincinnati golf course. It then demolished houses on Morton, Linwood, Grace, and Griest Avenues, crossed Delta Avenue, went through Ault Park, and went on to Red Bank, approximately three and a quarter miles.

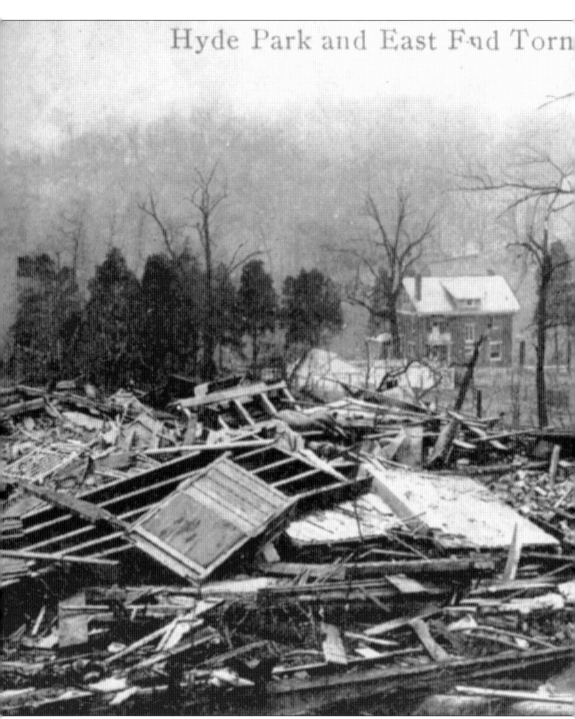

It being night, few saw the storm clouds approaching, but there were witnesses who saw a pear-shaped cloud of a dull red. The characteristic sounds of a tornado accompanied the winds. Roofs were carried away for 500 feet. A cluster of old trees was blown over and fell like the spokes in a wheel. Those trees and houses that were in the direct path of the storm were demolished. After the tornado had passed, a car was found that had blown from its garage and was lodged

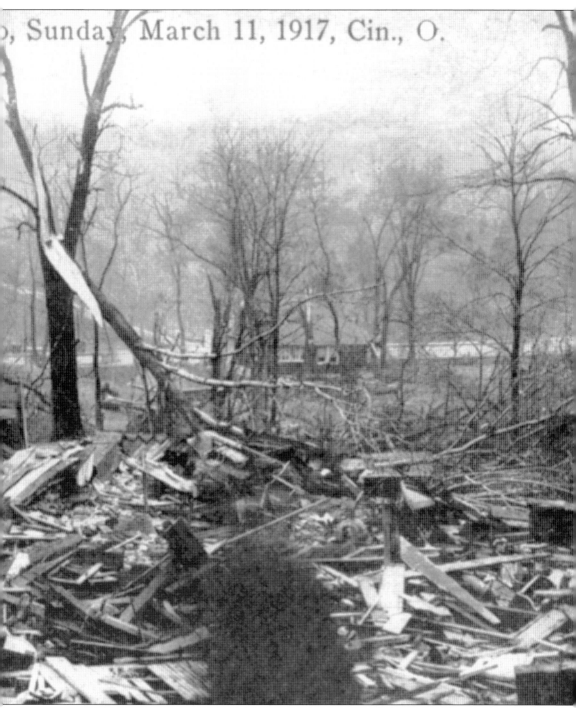

in a treetop. At One Grace Avenue House, the front-porch roof had been switched with the back-porch roof. William Rippey, an extract manufacturer living on Grace Avenue, heard a commotion outside. When he opened the front door, he was blown across the room, striking the opposite wall, which was then blown outward. His wife was blown through the front door. They both sat on the lawn amid the rubble of their neighborhood.

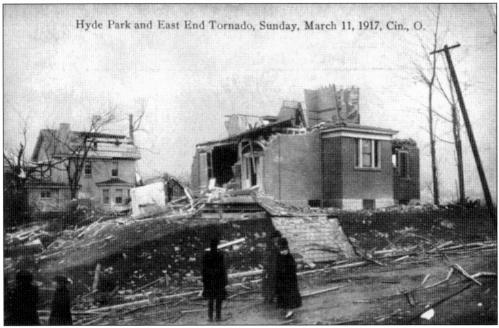

The tornado killed three people, injured 32, and destroyed 110 houses. A hundred homes in Hyde Park alone suffered damage. The property loss was estimated to have been $500,000. Earlier in the day, two tornados touched down in Montgomery County, also with loss of life and property destruction.

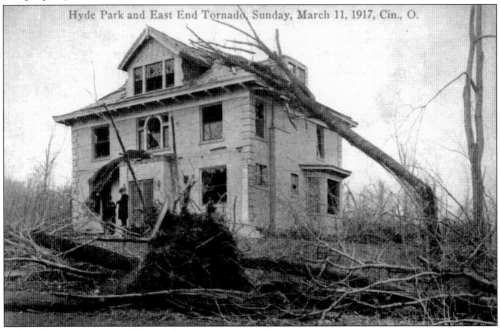

The following day the Hyde Park business club directors started a relief fund. One of the men killed was Omar Glenn, vice president of the Glenn Building Company, which owned the Glenn building at Fifth and Race Streets. The other two fatalities were Edward Walsh and Matthew McCarthy Jr.

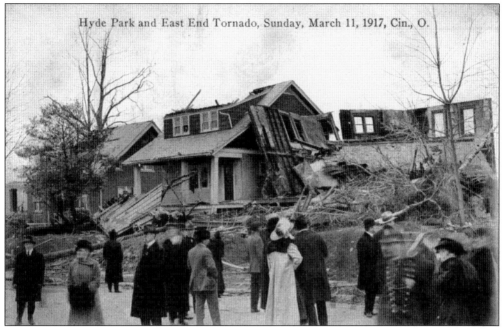

Harry Sayre owned this house at 1308 Grace Avenue. He was seriously injured and suffering from exposure when he was found.

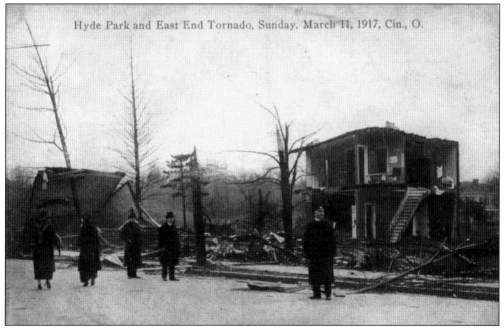

The tornado path was in the shape of a fan, anchored on Linwood Avenue and then spreading out along Grace, Griest, and Delta Avenues. Houses within a six-block radius of these streets were also heavily damaged, including Michigan Avenue.

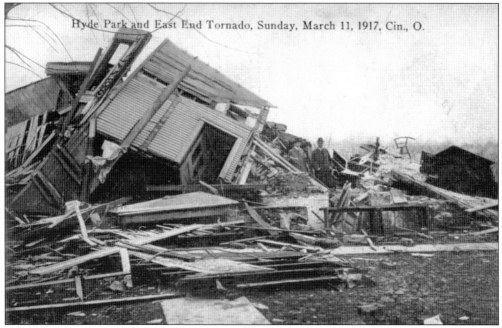

Hyde Park and East End Tornado, Sunday, March 11, 1917, Cin., O.

A ruptured gas line ignited on Grace Avenue. By the light of the flames, residents of neighboring houses could see the damage and called frantically for missing neighbors and family. In the midst of the fire and confusion, thieves tried to loot the ruins.

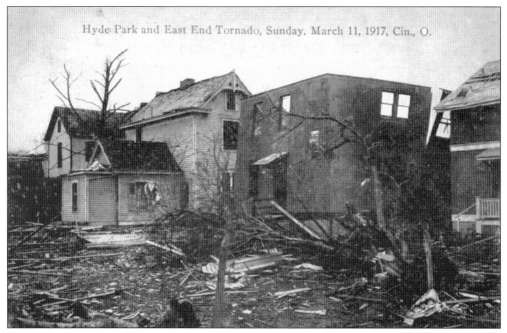

Hyde Park and East End Tornado, Sunday, March 11, 1917, Cin., O.

The following day, residents were burning debris and searching for household effects in the persistent rain. Carpenters for blocks were securing houses against the rainy weather.

110

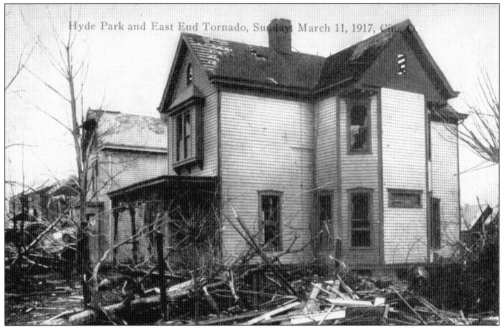

Myers Y. Cooper, builder, land speculator, and former state governor, donated $10,000 immediately for relief. A property loss of $500,000 was estimated.

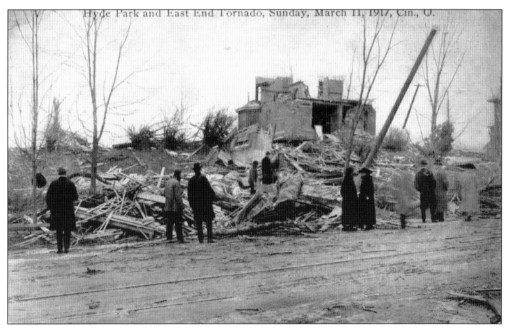

Horace Mann School on Cinnamon Street was also damaged and closed for a week. Not only was the roof damaged, but every window had been broken.

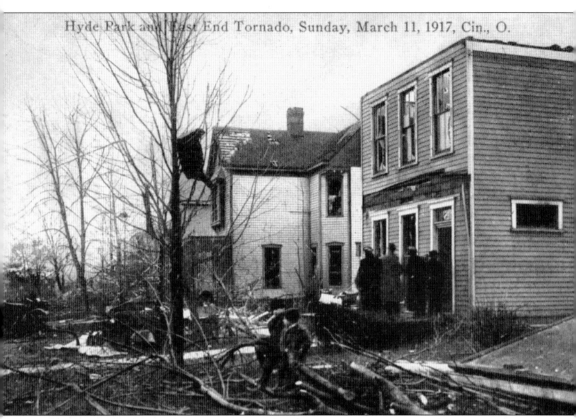

Hyde Park and East End Tornado, Sunday, March 11, 1917, Cin., O.

The Schneider family on Grace Avenue claimed that the house rocked as if it were a ship. The house had been twisted off its foundation. They escaped down a circular staircase that had been straight only an hour before. The Monroe homestead stood on the crest of the hill in Ault Park. A stone building with a roof observation platform to view the Miami Valley, the building was severely damaged by collapsed walls and was crushed by trees. Nearby sheds were gone, and window glass that was blown inward tore paintings. In the same newspaper that reported the news of the tornado, large advertisements were taken out by insurers advertising cyclone, tornado, and windstorm coverage at the rate of $6.40 per $1,000 for five years coverage.

Three

FIRE

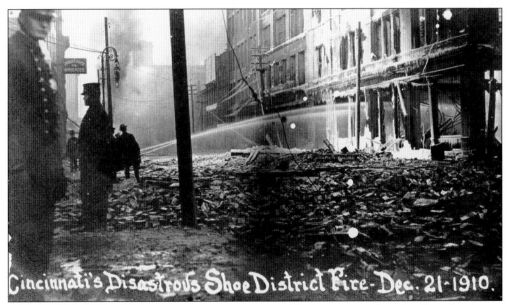

Cincinnati's Disastrous Shoe District Fire- Dec. 21-1910.

One of Cincinnati's largest fires, burning two city blocks, occurred in the shoe district on December 21, 1910. The area extended from Eighth to Ninth Streets and Sycamore to Broadway Streets. The fire started about 2:00 a.m. in the Krippendorf O'Neil (K&O) Shoe Company's factory at the southeast corner of Ninth and Sycamore Streets and soon engulfed the entire street, crossing alleys and fanned by the wind.

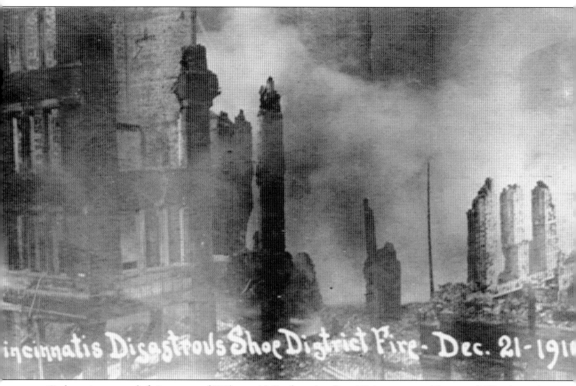

incinnatis Disastrous Shoe District Fire - Dec. 21-191

Only ruins were left in most of "Cheapside" after the fire. This was an old area of Cincinnati with very narrow streets and antiquated buildings. Because of the local meatpacking plant, Cincinnati had many leather tanneries and a large shoe manufacturing industry. One of the largest was the K&O Shoe Company, founded in 1904. Its loss of stock, machinery, and the building was so great that it did not rebuild. Other businesses damaged in the fire included the Twinlock Leather Company, Sycamore Street Stables, Victor Safe and Lock Company, E. O. Duncan Box factory, and A. Joseph Nurre Company, picture frames. The leather factory next to the fire station was destroyed. The Cincinnati Morgue, county jail, Payne Motor Company, and the Dow Warehouse were threatened. When the employees reported to their jobs the next morning, the 1,500 workers stood in shock at their job loss. Women cried as it was the week of Christmas and that paycheck was especially important. Even with all of Cincinnati's firemen working the blaze, it was out of control. Two blocks were engulfed and burned for nine days. Twelve were injured, four died (including three firemen), and the damage total was $2 million. (Courtesy of Don Prout.)

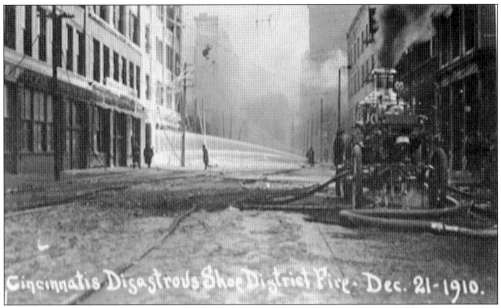

It was so cold that the forming ice created problems for firefighters. The original fire started in a basement engine room and quickly engulfed the factory via the elevator shaft. The Cincinnati Hotel across the street had broken windows in scorched frames and blistered paint. Three firemen died when a wall collapsed. One bystander perished when a telephone and light pole broke under the weight of ice on its wires. (Courtesy of Don Prout.)

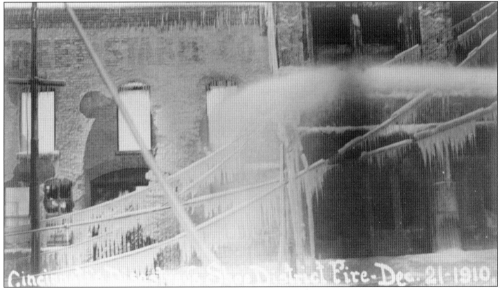

The fire was made worse by the lumber, solvents, varnishes, and paper stored in the various factories. Hampered by low water pressure, forming ice, and bursting water hoses, the fire was allowed to burn itself out. Thousands went out in the cold to watch the fire, which could be seen as a red glow in the night sky. The City of Cincinnati was glad to be rid of an area it considered an eyesore and health hazard, for it contained a short section of the canal that was a dead end. The land was bought by the City of Cincinnati and became the entrance of the Gilbert Avenue viaduct.

The chamber of commerce building (built in 1888–1889) was designed by Henry Hobson Richardson. It was the last of his designs before he died and was in his distinctive style named Richardsonian Romanesque. The unusual design had an iron truss under the roof's dome that ran east to west at the top of the building, and the floors below were suspended from this truss. When the fire reached a corner where the truss rested on the wall, the truss melted. All the floors collapsed upon each other, bringing down the south half of the building. The dome extended 40 feet above the attic floor. The Sinton Hotel, the Telephone Exchange across the street, and other nearby buildings had their windows broken by flying debris when the building's roof collapsed. Procter and Gamble lent a steel cutting machine to help cut through the twisted iron wreckage. Snow, ice, dropping temperatures, and winds hindered rescue attempts for those missing. The Cincinnati Chamber of Commerce was founded on October 15, 1839, when the city's population was 45,000.

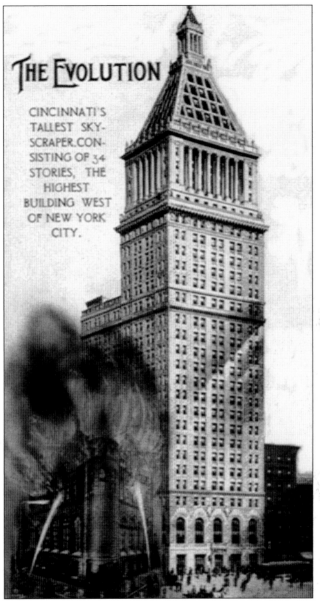

THE EVOLUTION

CINCINNATI'S TALLEST SKY-SCRAPER.CONSISTING OF 34 STORIES, THE HIGHEST BUILDING WEST OF NEW YORK CITY.

After the fire on January 10, 1911, the ruins were cleared and the Union Central Life Insurance building (now PNC Bank) was erected on the site. Before the fire, replacing the building was being considered, for it was too small for both the chamber of commerce and the grain and produce exchange. A 20-story skyscraper was the committees' vision. The ruins were unstable, and an elaborate rigging across the street to the Sinton Hotel and to the Mitchell Furniture Company next to the chamber of commerce was used to keep the tottering walls in place while hundreds of men searched for bodies. A tunnel was dug under a sidewalk grating in front of the Glencairn restaurant on Vine Street into the basement of the ruins where it was thought a victim lay. What they did find was thousands of bottles of liquor, champagne, and spirits, only a third of which had been broken. Crates of bottles were dragged out and when stacked, filled an entire room of the Gibson House next door. Huge crowds watched the building's progress while pickpockets plied their trade.

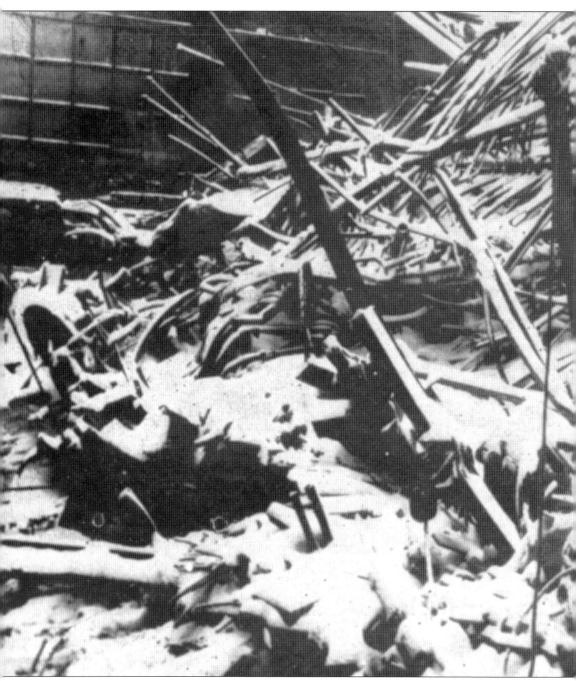

The property loss was $1 million, and six people died. Water was played over the hot granite stones for a week before the fire was completely extinguished. As a result of the fire, changes occurred to the municipal fire code. Elevators and stairs had to be enclosed, fire hoses routinely checked, and iron/steel girders were no longer to be left exposed. The cause of the fire that brought the great building down was a grease fire in the kitchen of the Businessmen's Club. A large banquet was being held, and on the kitchen ceiling a small flame was noticed and doused with water, but it reignited. The flames spread. Within 10 minutes the upper part of the building

was engulfed. The area under the dome was used for tenant storage, a use not anticipated nor designed for, which fed the flames. The alarm was sounded and the building's fire hoses were used by firemen and employees, but the hose fabric was rotten and burst. Granite blocks were saved from the ruins, and a few were reused for the Richardson monument in Burnet Woods, across from the Design, Art, Architecture, and Planning Building of the University of Cincinnati. Stone eagles that originally flanked the dormer windows were placed on each side of the Melan Arch Bridge at Eden Park.

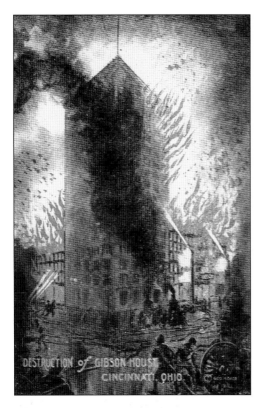

DESTRUCTION of GIBSON HOUSE
CINCINNATI. OHIO

The Gibson House hotel fire consumed nearly a city block on December 11, 1912. The hotel, built in 1835, was being remodeled, and a portable stove the workmen used for heat was not properly extinguished, igniting construction materials and tar paper nearby. Adjoining the hotel was the Union Savings Bank (now Bartlett) building, at Fourth and Walnut Streets, designed by Daniel H. Burnham of Chicago in 1900. The upper floors of this building also caught fire. No lives were lost, although property damage exceeded $1 million. Fighting the fire were 22 engines, four hook and ladder companies, two water towers, and 237 men.

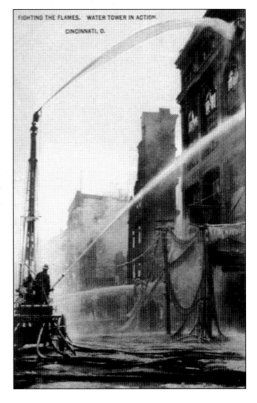

FIGHTING THE FLAMES. WATER TOWER IN ACTION.
CINCINNATI, O.

A water tower was necessary to fight fires in tall buildings. It proved inadequate for dense fires and tall buildings. Buildings, such as those seen in this chapter, were constructed before the city had a building code. Those in the shoe district may have been tall but were only a few bricks in thickness. Weakened by floods, with merchandise-overloaded floors, these walls could collapse during a fire, often burying firemen. (Courtesy of Don Prout.)

Four

EARTH

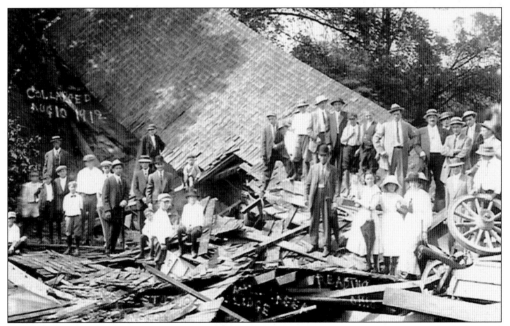

Hatka's covered wooden bridge, in Reading, collapsed on August 10, 1912. It spanned Clark Road connecting south Reading to Arlington Heights. The bridge failure was attributed to overloading. The wagons were owned by James McJoynt, a Norwood contractor, and were hauling cinders. The wagons and horses fell 25 feet into the Mill Creek, and the three African American men handling the wagons were injured. The horses were unhurt. (Courtesy of Don Prout.)

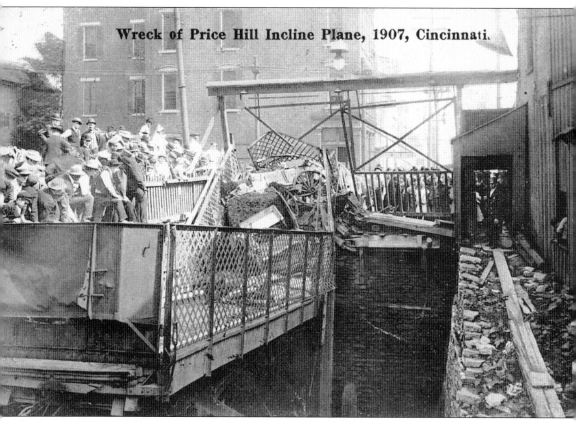

Wreck of Price Hill Incline Plane, 1907, Cincinnati.

The Price Hill freight incline broke a cable on Sunday, October 2, 1906, crashing two men and their wagons to the ground. Price Hill had a double incline, one for people (1875) and the other for freight (1877). At the top of "Buttermilk Mountain" was the Price Hill House, which served no alcohol because the incline's owner was a teetotaler. But at the incline's bottom was the Last Chance Saloon, for those ascending. For those going down the hill, across the street from the Last Chance was the First Chance Saloon. The 1906 accident occurred when the one-inch steel cable broke while pulling an ascending freight car loaded with a wagon of manure, a wagon of sand, four horses, and Joe Strasell and Edward Brisker, wagon drivers. Nearly 50 feet from the top platform, the cable wires parted, sending the cable to whip back and forth across the tracks. The other car ascending ran into the top platform, narrowly missing the machinery operator as it crashed into his shack. The emergency cable also failed. Both drivers survived by falling backward into their loaded wagons, but the horses had to be put down. Afterward the drivers were hurried off by a cheering crowd to partake at the First Chance Saloon, where drinks were on the house.

Street Car Wreck, Elberon Ave., 1907, Price Hill, Cincinnati.

The Warsaw streetcar accident on New Years Eve of 1906 was one of the worst for the Traction Company. The brake chain broke going down the long hill, and the brake shoes were excessively worn. The front motorman was James Hall, and the rear conductor was James Lowman. Both acted heroically to keep the passengers calm, but there was little they could do as the careening streetcar swung into a curve, left the tracks, fell over, and hit a trolley pole, splitting open the carriage. Every person was injured but only two seriously enough to die, and nine to be hospitalized. Neighbors heard the noise and rushed out of their homes to assist the injured. This accident underscored that the city needed ambulances and more patrol wagons. While the grand jury found gross negligence, the court ruled that the Traction Company could not be indicted because there was no applicable statute to cover this case. The street name on the postcard is in error.

Explosion of Dynamite, near The Altenheim, Avondale, Cincinnati, 1907.

The explosion of 250 pounds of dynamite in Avondale on Sunday morning, March 18, 1907, shattered windows and moved houses from their foundations. Many were rolled from their beds thinking Cincinnati was experiencing a great earthquake or that a comet had fallen. A shed holding dynamite used for blasting rock on the site of the new General Hospital at Burnet and Goodman Avenues was supposedly set ablaze by a disgruntled employee, or employees. It exploded at 1:20 a.m., leaving a conical hole 10 feet deep and 15 feet across. The blast was heard as far away as Hyde Park, Glendale, Wyoming, and Norwood, as well as Fort Thomas, Kentucky. Windows within a mile-and-a-half radius shattered and those of stained glass fell into tiny fragments. Plaster fell from ceilings and walls. Slate roofs were damaged. Sewer pipes broke. Splinters from the wooden shack that held the dynamite were found embedded in trees a block away. Insurance policies of the time did not cover the damage. The Altenheim (German old men's home) had $10,000 worth of damage and asked for public donations. The day following the blast an estimated 50,000 people came to view the damage. There was no city ordinance covering the storage or use of dynamite.

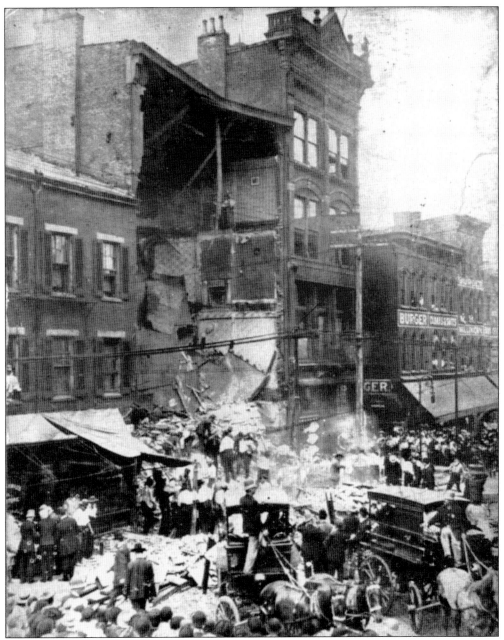

The facade and 35 feet of walls of this building at 625–627 Central Avenue collapsed on September 14, 1907. A four-story double building, it tumbled without warning. A passing pedestrian was killed by the falling walls along with two residents. The tenants lost all their possessions. Thousands came to view the ruins, and apartment dwellers across the street sold quarter admissions to better see the salvage efforts from their higher windows. The building was being renovated on the first floor to form one large store from two smaller ones. The crash was the result of the foundation wall buckling, thus dislodging the center weight-bearing girder. Two-thirds of the building's walls came down. The ground floor store was for Dohan's Shoes, and the Dohan family owned the building.

The May 1913 transit strike angered many. The strikers wanted increased wages, better working conditions, and union recognition. Here crowds are milling around a stopped streetcar at Fifth and Walnut Streets. Violence marred this strike. A streetcar was derailed and stripped in front of the L&N department store downtown. Another one was pelted with bricks, pipes, and stone from the Union Central Life Insurance building, then under construction. Several streetcars were stripped and burned. The strikers were joined by sympathizers and the curious. Sometimes the tracks would be blocked with wagons or trucks, thus stopping the streetcars from proceeding. Two streetcars from Avondale at Sixth and Sycamore Streets were boarded and the trolley lines cut. Some interurban lines were also shut down. Downtown businesses reported a decline in sales. The Ohio National Guard was ready at the 1st Regiment armory to mobilize should they be called upon. As the strike lingered, more strikebreakers were brought in from Chicago by the Traction Company. In one case, every worker who would join the strike had a red carnation pinned to his coat. (Courtesy of Don Prout.)

"Strike! I walk" proclaims this jaunty woman. This is a composite postcard. The figure was cut from another postcard and pasted on the streetscape. The day following the strike's beginning, two-thirds of the motormen were not on the job. Seventy-five extra policemen were sworn in to help with the crisis. Crowds of demonstrators walking to carbarns would often be joined by those forced to walk to work. (Courtesy of Don Prout.)

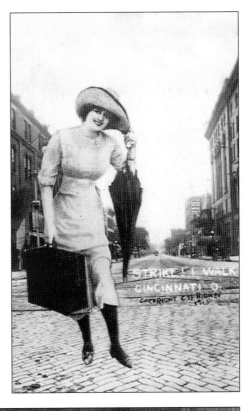

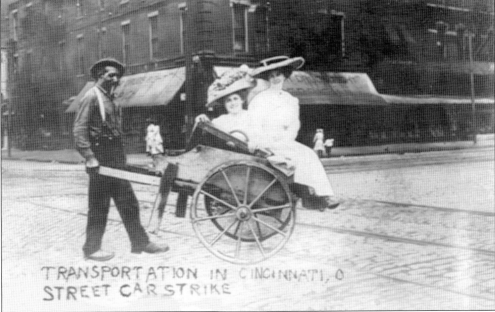

Here is another humorous composite postcard commemorating the 1913 strike. The Hyde Park business club used automobile trucks, each holding 50 passengers, to run between their community and downtown. The strike lasted 10 days. After it was over, grateful citizens tossed bouquets of flowers at streetcars. (Courtesy of Don Prout.)

ACROSS AMERICA, PEOPLE ARE DISCOVERING SOMETHING WONDERFUL. *THEIR HERITAGE.*

Arcadia Publishing is the leading local history publisher in the United States. With more than 3,000 titles in print and hundreds of new titles released every year, Arcadia has extensive specialized experience chronicling the history of communities and celebrating America's hidden stories, bringing to life the people, places, and events from the past. To discover the history of other communities across the nation, please visit:

www.arcadiapublishing.com

Customized search tools allow you to find regional history books about the town where you grew up, the cities where your friends and family live, the town where your parents met, or even that retirement spot you've been dreaming about.